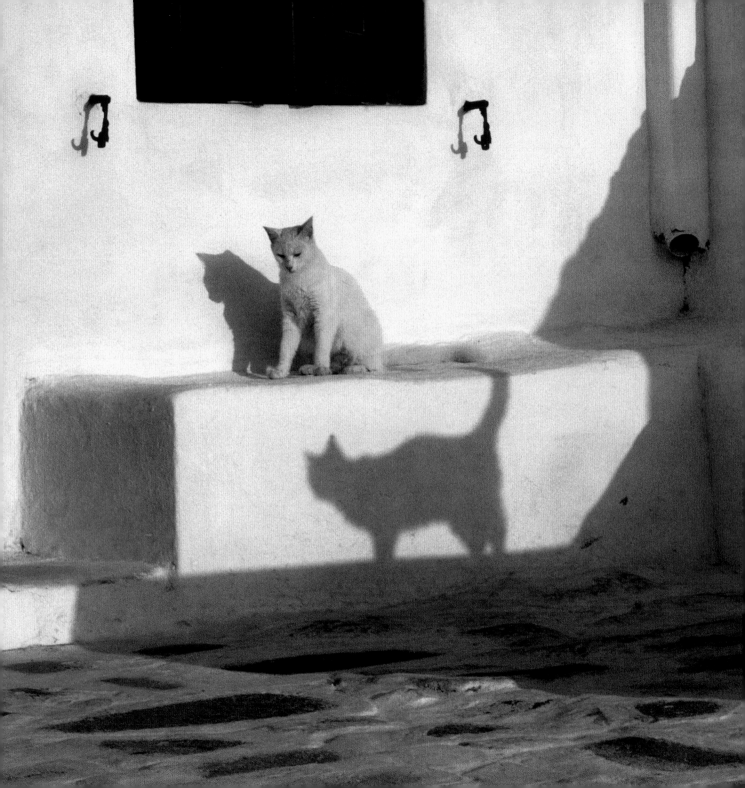

Cats *in* Love

HANS SILVESTER

CHRONICLE BOOKS

SAN FRANCISCO

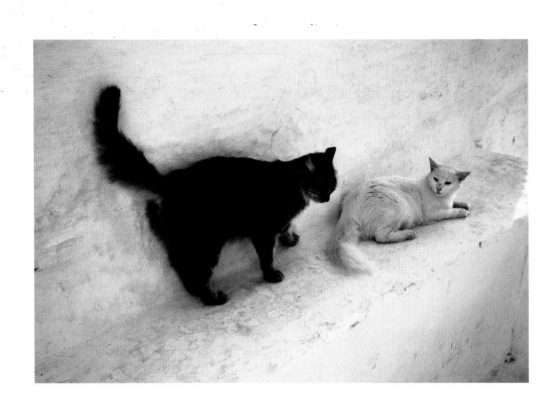

IN 1994, THE FANTASTIC DISCOVERY OF A CAVE IN ARDÈCHE revealed the work of the earliest known artists in human history. The paintings in the cave of Chauvet are between thirty thousand and thirty-two thousand years old and depict a menagerie of animals both alone and in groups. It was a big surprise to find that one of the works, a drawing of a pair of lions, presents more than just simple likenesses—it depicts a lioness in heat rubbing herself against the mane of a male, clearly pursuing him. The fact that the artists chose to illustrate the lions' amorous behavior, rather than just the cats' body shape and appearance, suggests that it was the lion, over any other creature, that most impressed humans of the time. One can only be astonished and excited by these images, both by the artists' gift of observation and by the quality of their execution. Such amorous behavior of cats has not changed much in the last thirty thousand years. The pairs of cats shown here bear the same expressions as those in the cave of Chauvet.

Whether one lives in the city or in the country, everyone has been awoken at some time or another by the terrible yowling of two tomcats fighting over territory. In years past, when cats roamed more freely than they do now, and when there were fewer cars, you could open a window and throw a bucket of water on them, in an attempt to reinstate calm. This never actually settled the conflict, though, for every time two tomcats meet—particularly during the mating season—there is a confrontation.

All male cats dream of having their own territory, complete with female cats that belong only to them. Unfortunately, however, hostile encounters and jealousies between tomcats are an unavoidable part of life. When two tomcats cross paths, each displays great displeasure at finding another in the same territory. Face to face, fur standing on end, they approach one another slowly, as in a slow-motion film, never taking their eyes off their opponent. When they are standing but a few inches apart, they begin meowing and hissing at the top of their lungs, sometimes for several minutes at a time. The confrontation usually ends when one of the two cats backs away. Sometimes, though, the conclusion is not peaceful, and one of them jumps on the other, starting a serious brawl. This is combat between adversaries equipped with formidable weapons. The fur begins to fly as the cats fight fiercely with razorlike claws, biting each other on the neck and near the ears. And then, in disturbing silence, the rivals tangle in a ball on the ground, each trying to do the other as much harm as possible, often wounding each other quite seriously. After such violent fighting, they are both looking for an excuse to end the combat. At this point, only an external distraction, such as the approach of a person, can interrupt the fight and allow both cats to leave without losing face.

There is only one exception to this confrontational behavior: There are a few cats so strong, so violent, so cruel, that their opponents prefer to pretend that they do not see them and walk the other direction. Ironically, of course, such reputations are only acquired through merciless fighting.

Males go to great lengths to establish their territorial claims and attract the attention of females by regularly marking their domain with urine. Paradoxically, conflicts between males come to an end when they find themselves in the presence of a female in heat. At this point, territorial issues become secondary and males occupy themselves with more important things: impregnating the female cat and ensuring the continuation of the family line.

The difference between male and female feline physiognomy is slight. Tomcats have rounder heads and muscled bodies and weigh more than females, who tend to be more slender and graceful. For a female cat, the few days spent in heat are difficult. She is attracted to males, but she is also afraid of them. She often encounters more than one tomcat, who can pick up her scent from far away and may cross long distances to find her. It is the older, more experienced tomcats who ensure reproduction; the younger males must be satisfied by observing from a distance. The act of love itself is brief. It always ends with the panicked departure of the female, who flees the scene as fast as possible, usually pursued by several toms. Sixty-three days later, kittens in a litter bear different colors and patterns, after their respective fathers. Sometimes none of the kittens in a litter looks alike!

Such is the life of cats in the narrow little streets of the villages of the Greek islands. However, cats' relationships are not limited to such intense—and noisy—moments. Outside of mating season and territorial disputes, friendship and camaraderie do exist among cats. In fact, it's surprising to what degree cats' relationships resemble our own.

After years of observation, I can confirm that love between cats exists. Such tenderness and affection as cats display is rare in the animal world. Cats greet each other by brushing up against each other. They groom each other's coats. They often sleep curled up together, tightly entwined, deriving great pleasure in lazing about in each other's company. Physical contact elicits great pleasure and appears to count for a lot. It's easy to understand why—most of us are acquainted with the pleasure of petting a cat. A positive current passes between the two individuals, cat and human, producing a strong feeling of well-being in both. In fact, petting a cat may even lower blood pressure. And the cat finds his bliss impossible to hide, purring loudly to tell you about it.

Feline affection is possible in every sort of combination: a mother and her kittens, a female and a young male, two young males, a brother and sister, two cats of different ages. (The only cats who never seem to become friendly toward each other are a female in heat and an older male.) I have observed a few pairs who enjoy each other's company so much that they rarely leave one another's side, day or night. Often, these pairs will not tolerate the presence of a third cat, who might encroach upon their happiness. Cats in love emanate amity and trust. They may even rediscover their childhood, remembering how it was to be a still-blind newborn kitten—warm, well-fed, safe, and secure, being groomed affectionately by their mother.

Cats are not pack animals. They prefer to live in a small

group or family, existing together with hardly any tension at all. Older males prefer to live a bit apart. Within a group, there is no dominant leader; connections and friendships develop based first on blood ties and then individual affinities. A mother cat, for instance, remains strongly attached to her young, and brothers and sisters continue to show affection for each other, even after they grow up.

Sometimes, two cats will raise their kittens together, sharing litters, caring for each other's progeny with the same love and affection as their own. In spite of the fact that the kittens may not resemble one another at all, with diverse fur color and length, a mother naturally recognizes her own young. Generally, this parenting arrangement works out quite well. The two mothers protect their offspring together. As long as the kittens are little, no male—not even the father—can approach, for the furious mothers will immediately chase away the intruder. For when a cat becomes a mother, the kittens become her pride and joy, and she is prepared to defend them with an incredible courage; she will even throw herself in front of a menacing dog in order to protect them. But as soon as the little ones become a bit more independent, the mother's attitude softens, and fathers often meet their offspring, young and old sniffing each other with curiosity and respect.

To those who live in the Greek islands known as the Cyclades, the presence of cats is just part of life. In the tiny streets, on the fishing docks, atop flat roofs, cats live their lives in harmony with humans, with almost no interference from them. The island architecture suits cats perfectly: the villages are filled with outdoor staircases, terraces, little gardens, and narrow streets that allow them to drift from one household to another.

These cats are not house cats, but they are not feral either—they are domesticated, just less so than our pets. Some belong to families but, for the most part, are simply the village cats. Residents who give them attention are amply compensated: the cats delight in hearing affectionate words from their human admirers. Few let themselves be petted, however, being too timid and fearful. It takes time to truly gain their trust.

The island fishermen are usually quite generous to the cats, giving them any damaged or unmarketable fish. And, in every village, kindhearted elderly men and women make the rounds feeding the cats. Nevertheless, the life of these animals is very difficult, especially in the wintertime, when many residents leave the islands for Athens. Tourists play an important role in the support of the cats, for many take pity on the creatures and feed them. Some even adopt them and bring them home. I myself adopted two cats, Gréco and Hydra, who have both adapted very well to life in Provence.

The real problem for these cats lies in overpopulation. In favorable years, the majority of the kittens reach adulthood, causing the population to swell—doubling or even tripling. Food becomes insufficient, illness thrives, and only the strongest survive. Over the centuries, cats have survived the brutal system of natural selection. While it is often very difficult for visitors to

accept, the Greeks generally do not wish to interfere in this natural cycle. The idea of killing a percentage of the newborn kittens to prevent overpopulation is readily rejected. Spaying and neutering is not a viable solution either, because most of the islands do not have veterinarians. However, having visited the Greek islands regularly for the past twenty years, I have noticed that the mentality of the residents appears to be gradually changing, and they have begun to address these issues.

The villagers do make use of the cats' natural hunting abilities, giving them a little food in the hopes of ridding the villages of mice and rats. The idea for this arrangement was borrowed from sailors, who kept at least one cat on board ship to protect the crew's provisions from rodents. (This is how all of the islands became inhabited by cats—for cats prefer terra firma to seafaring ships and, being cunning escape artists, will always flee at the first opportunity.) Indeed, cats are effective at catching mice, able to catch and eat up to twenty mice per day!

The Greeks close their homes to cats and show little interest in petting them. However, children and cats enjoy each other's company and often play together; adults rarely interfere, letting them do as they please. When the islanders see the cats being affectionate or amorous, they find it quite amusing; the more the cats' behavior resembles that of humans, the more the islanders appreciate the cats. Thus, in Greece, I began observing and photographing cats in love, and this book was born. Over the years, they constantly surprised me, giving me a glimpse of their joie de vivre. I found that I was able to understand them: to have such tender relationships, to live so intensely—is sheer bliss.

The range of emotions in cats is broad: indifference, respect, amity, antipathy, tolerance, curiosity, friendship, and love. One cat can recognize another from very far away, immediately taking stock of the other's emotions and reacting accordingly. If she is running into a friend, she will approach in a straight line with tail raised in the air, and they will greet each other by rubbing heads, displaying the pleasure of meeting again. At other times, cats can be remarkably aloof, one refus-ing to acknowledge another by pretending to look in the other direction.

A solitary cat, however, becomes frustrated by the fact that it cannot communicate. Although the presence of a human is helpful, it cannot replace the relationship with another cat, chosen on the basis of personal preference. People can be very kind toward cats who are more or less domesticated—spoiling them, pampering them, befriending them—but the cat will always remain nostalgic for those moments of happiness shared with his fellow felines.

Harmony can also be found in the way that cats play. Cats who know each other well play wonderfully together. For those less well acquainted, playing can often quickly turn into a spat. In the playful disposition of cats, expressions of love and hate are both part of a game. Play is an integral aspect of life—even very old cats continue to play. For kittens, of course, playing is the school of life—it is through play that mothers teach them the basics.

But perhaps the most striking expression of love between cats occurs when they are relaxing or sleeping. It is in these moments of total intimacy, nestled together tight as can be, drowsing tranquilly, that they become one.

Cats have always lived in the Cyclades, where their antics continue to animate the lives of the residents. Cats are an element of the island landscape, like the wind, the sun, and the sea; they are a constant, like the coming of day and night.

—Hans Silvester

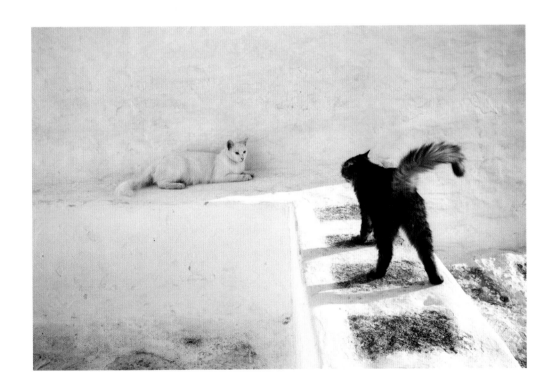

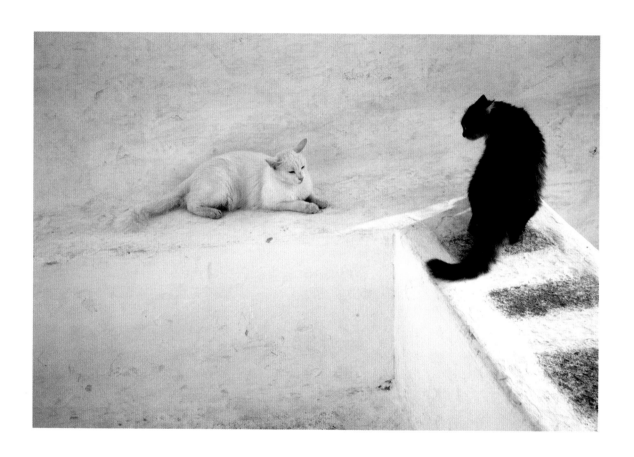

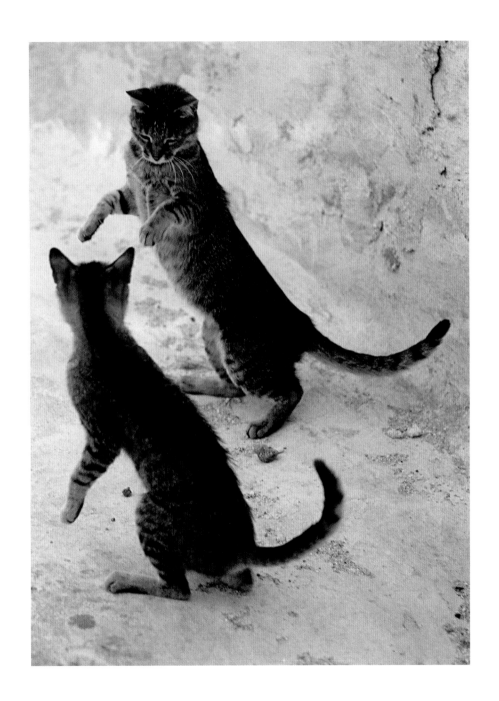

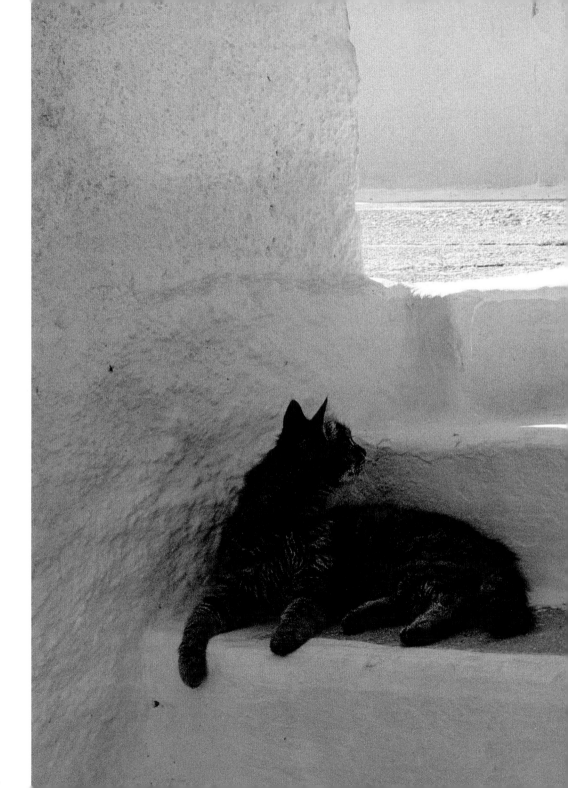

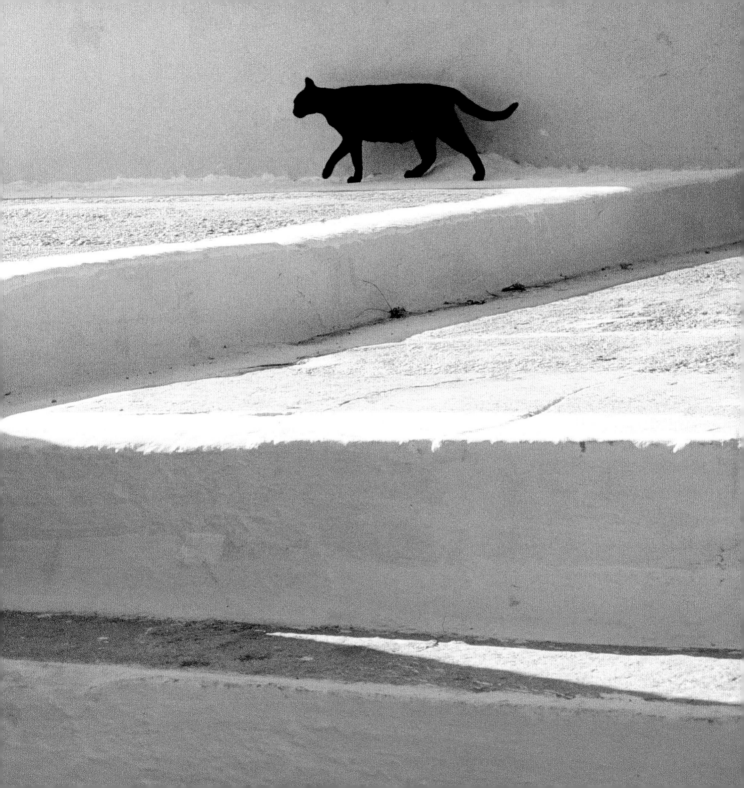

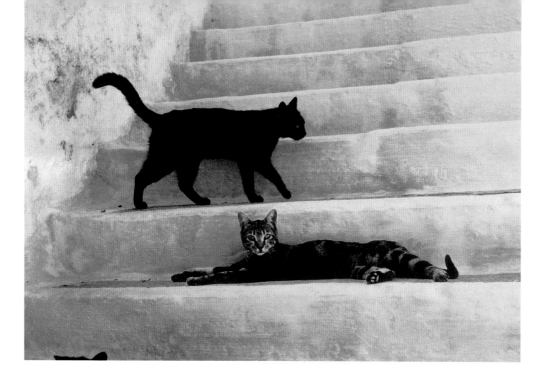

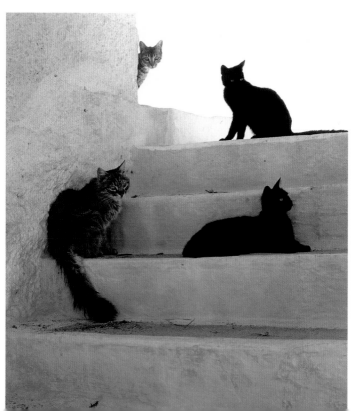

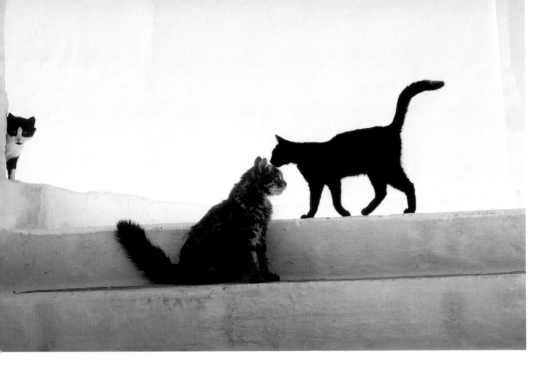
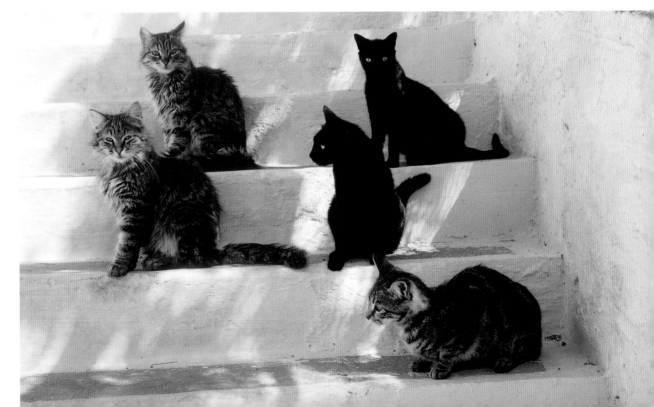

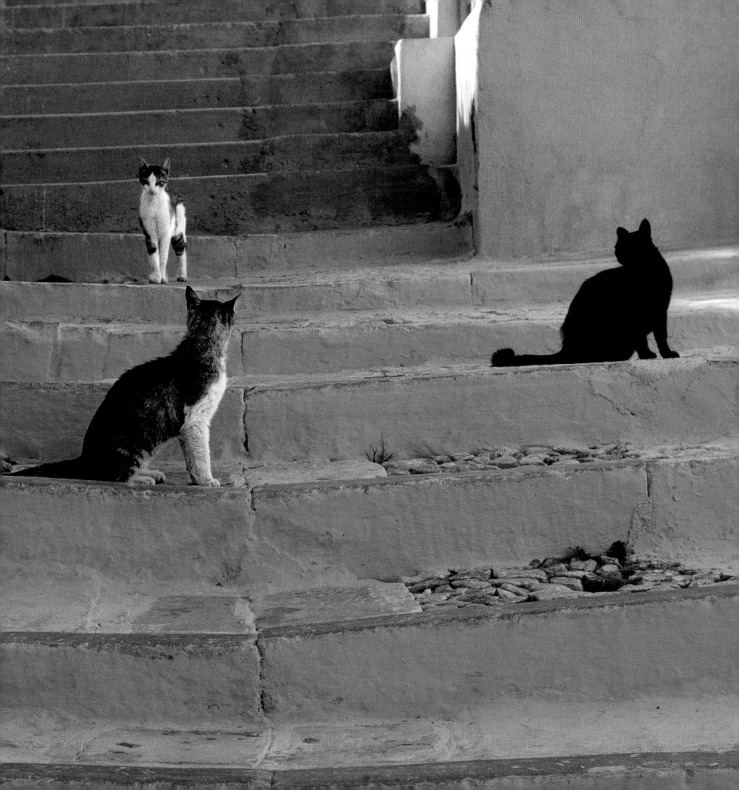

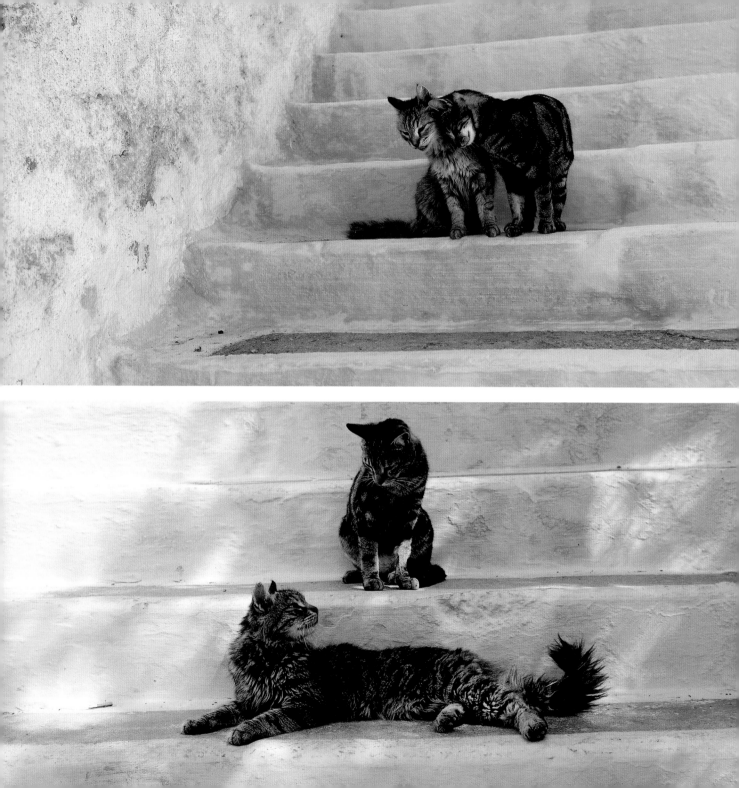

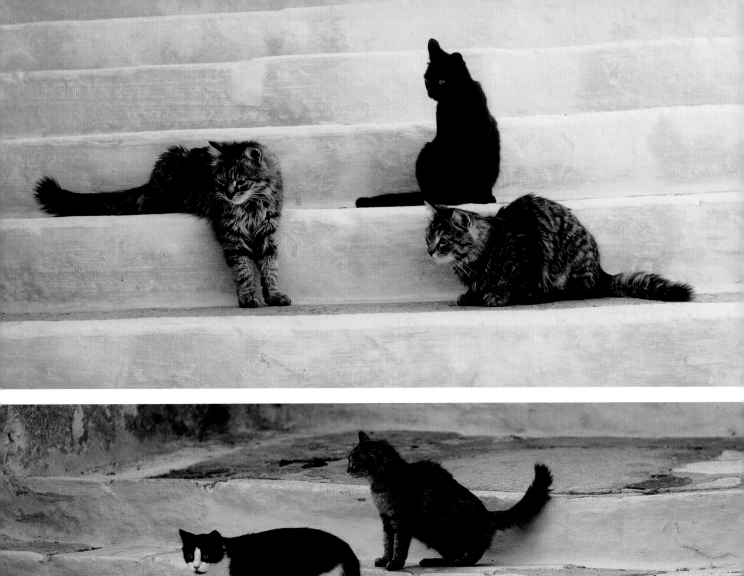
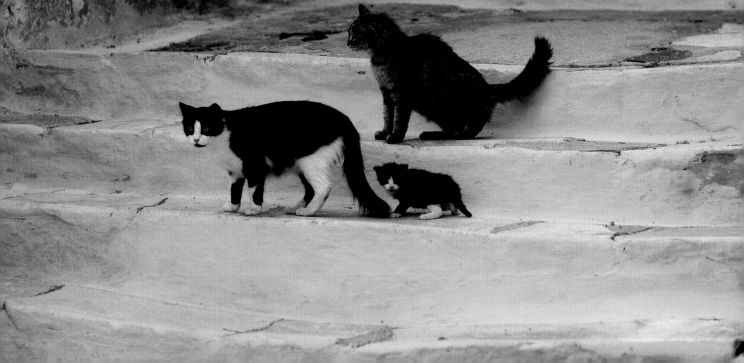

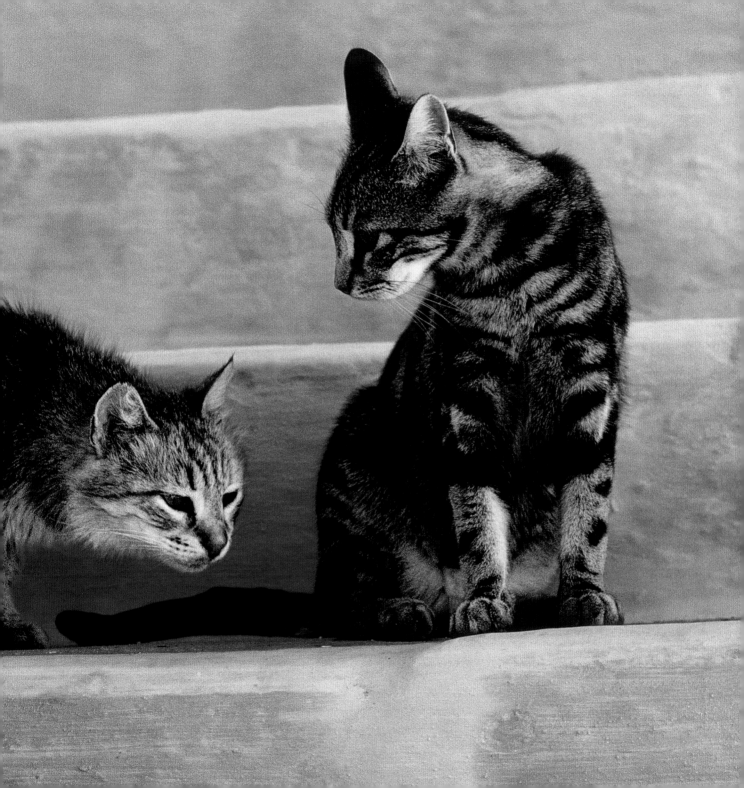

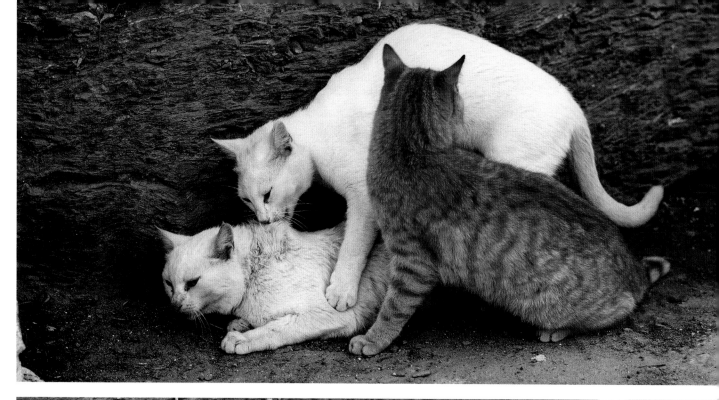
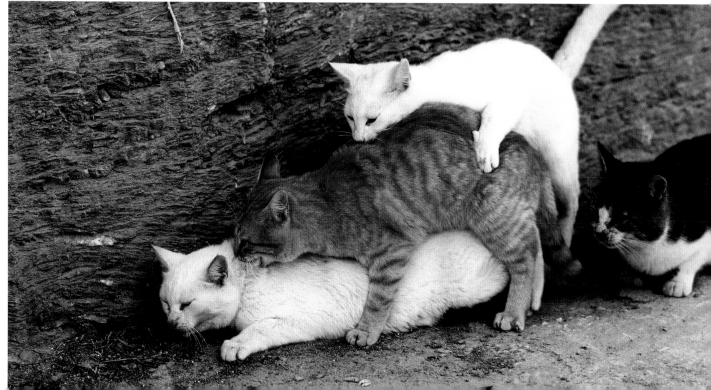

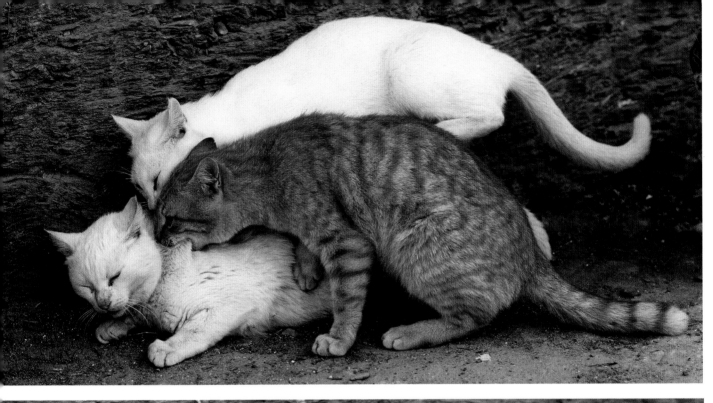

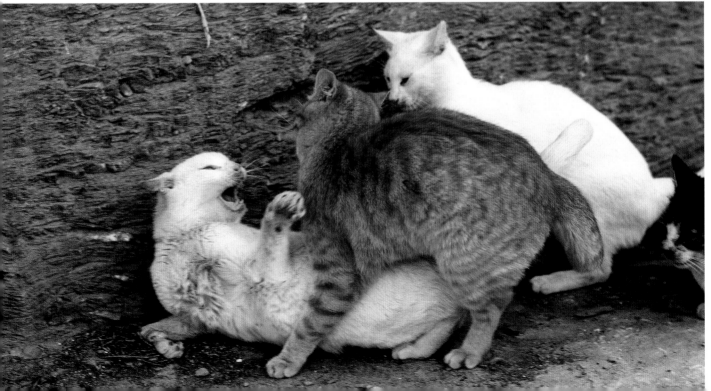

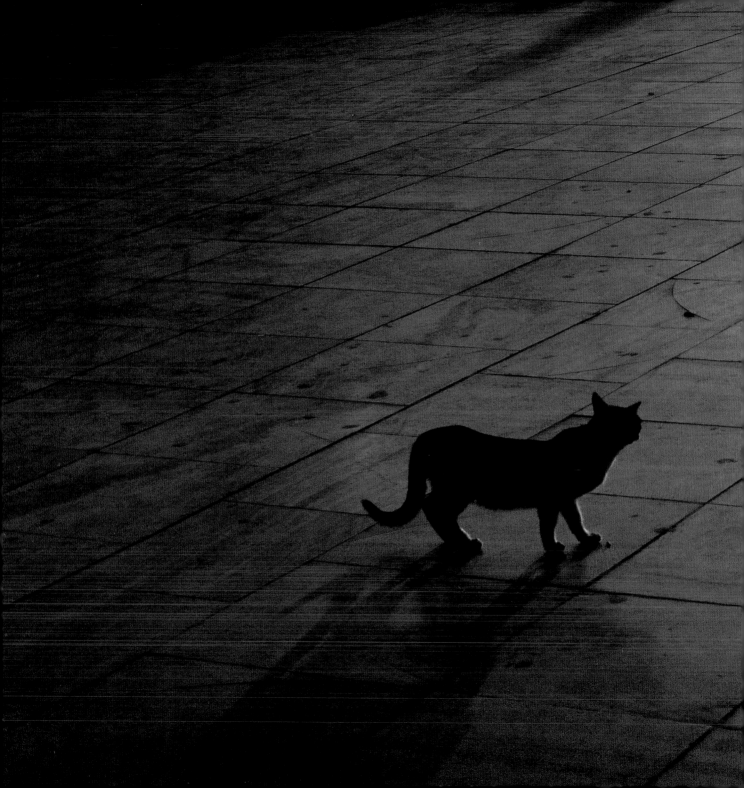

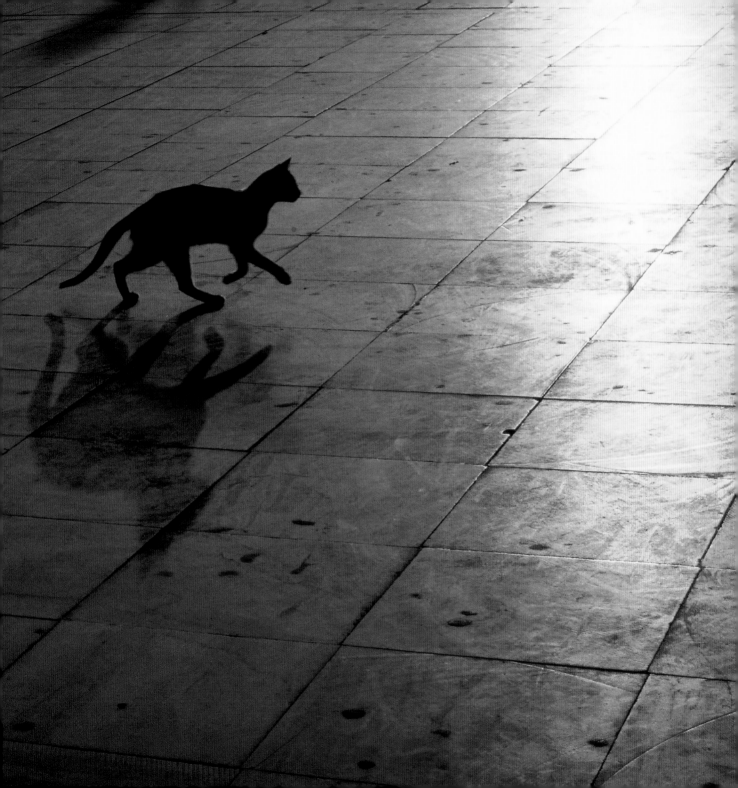

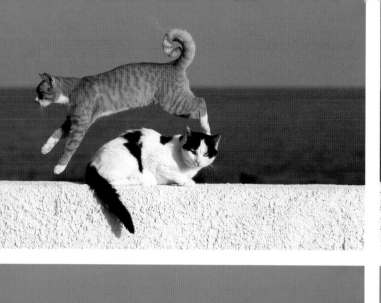
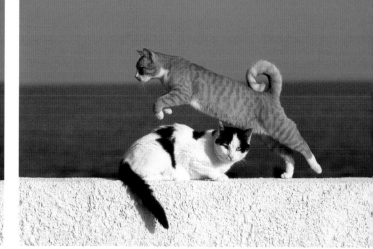
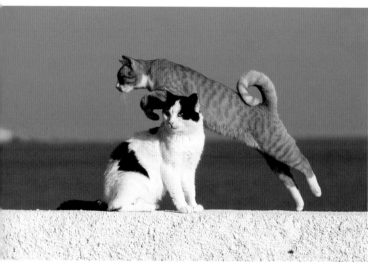
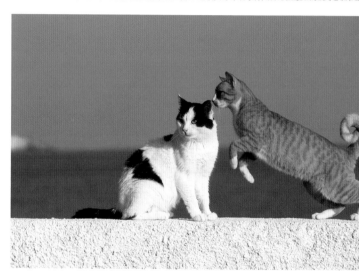
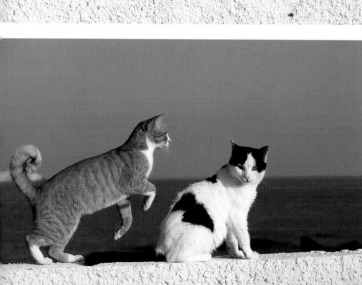
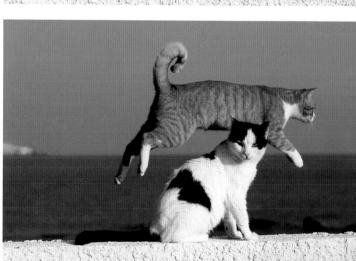

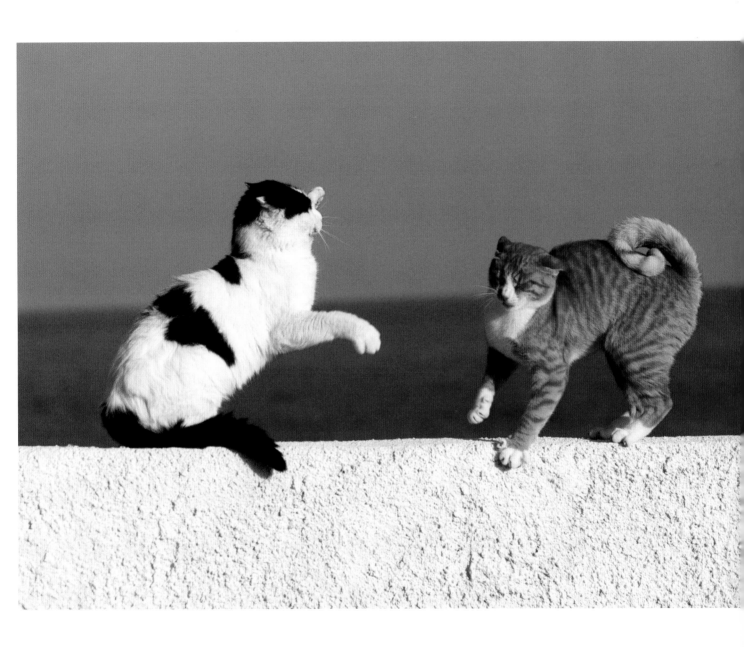

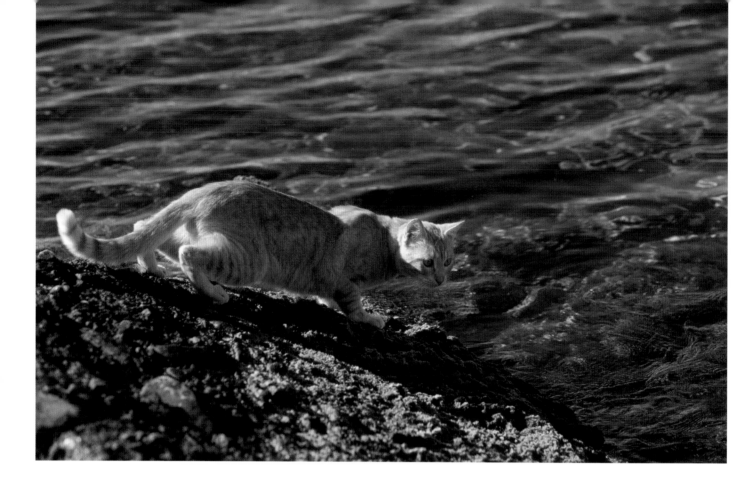

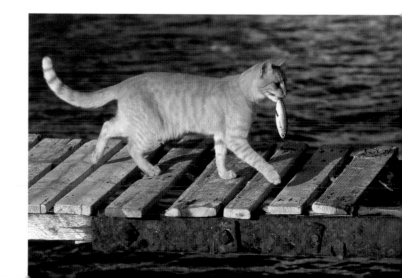

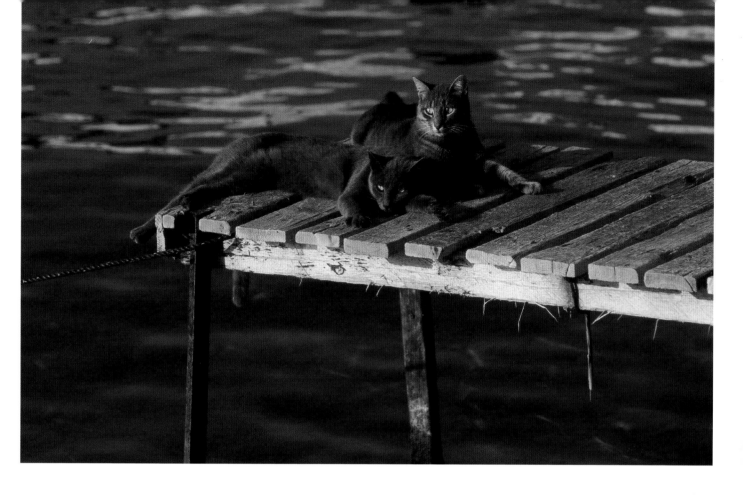

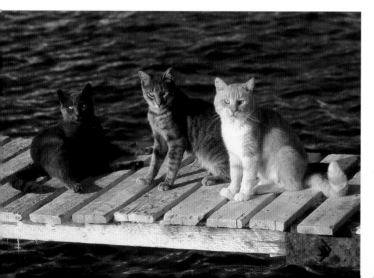

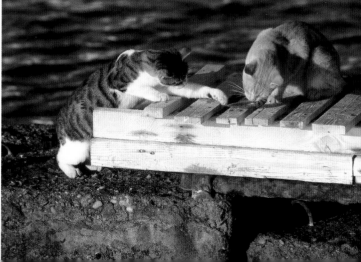

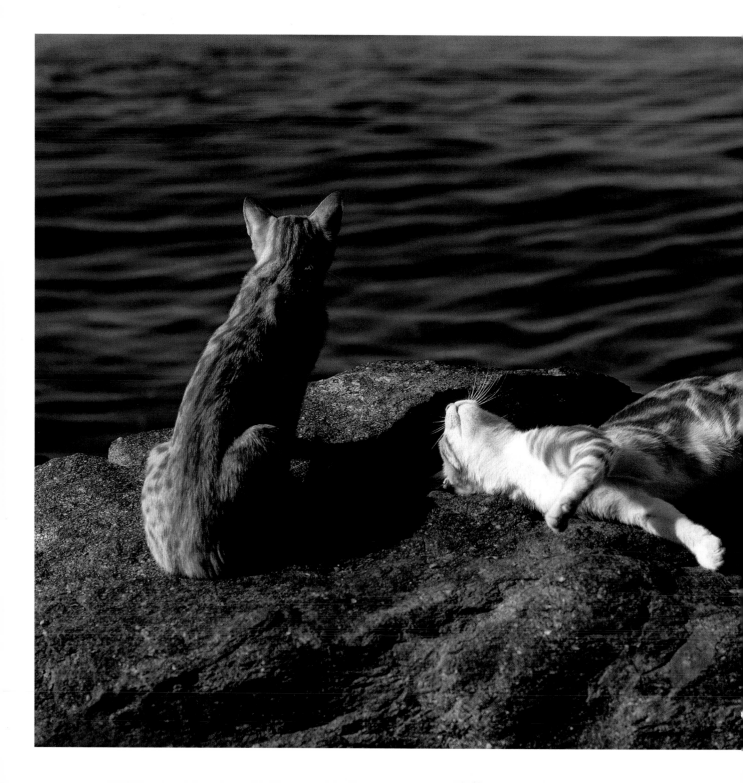

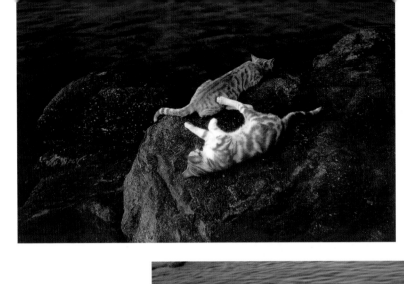
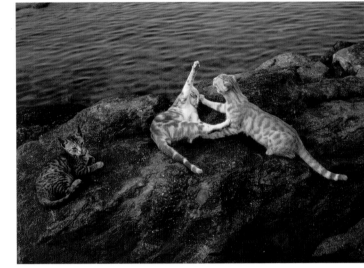
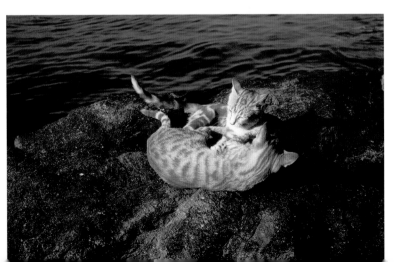

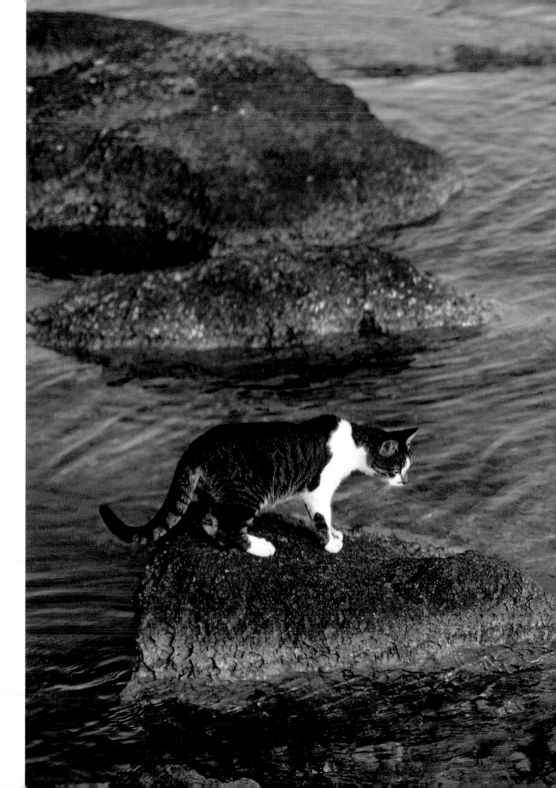

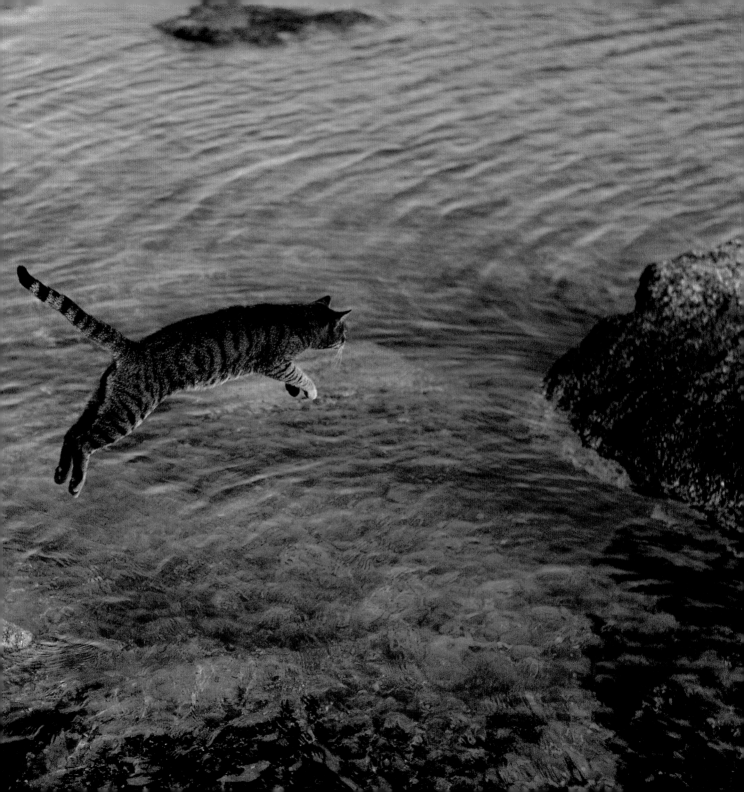

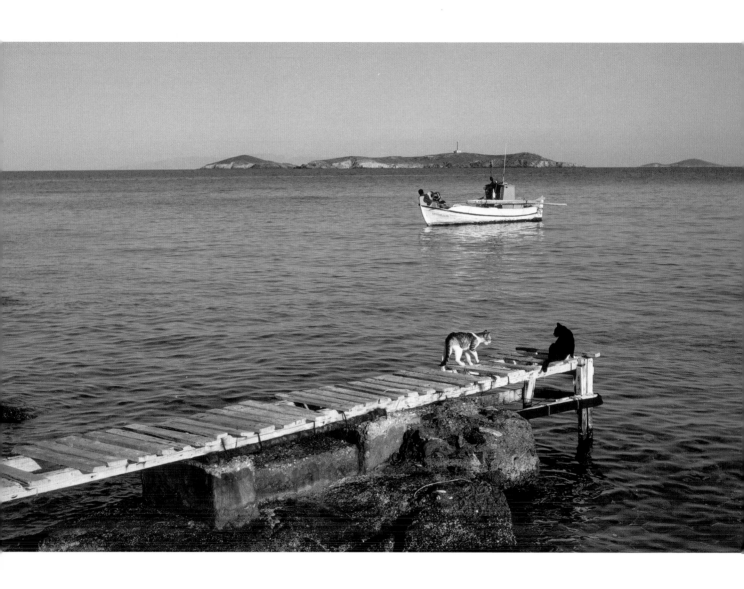

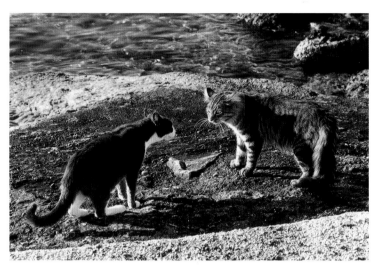

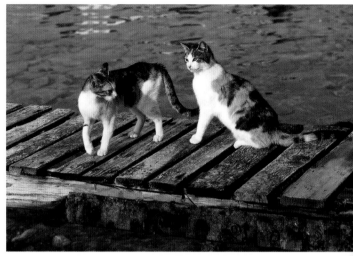

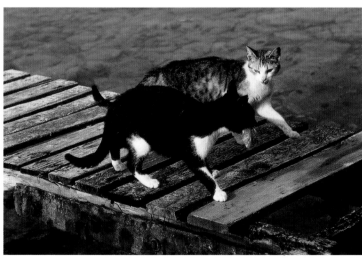

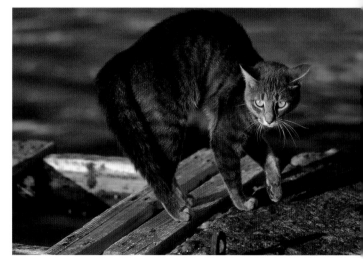

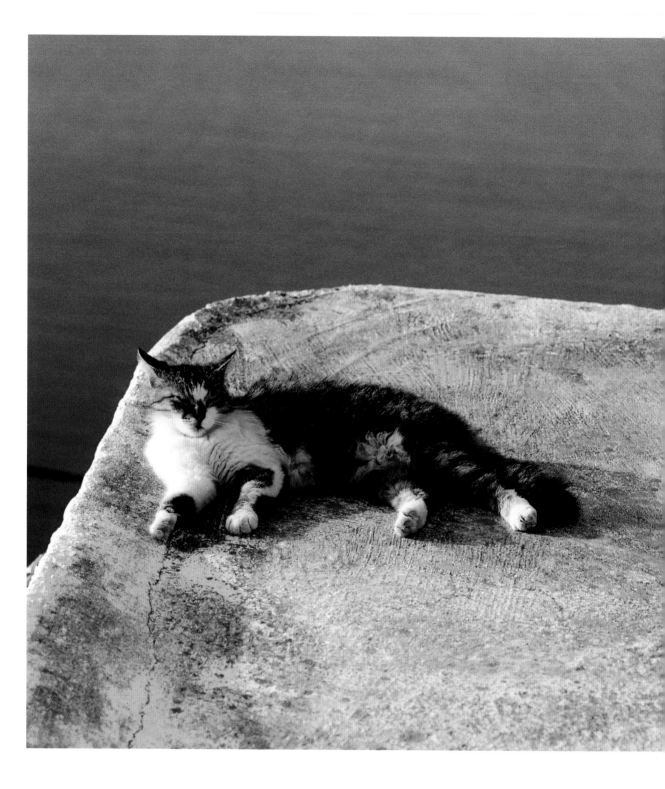

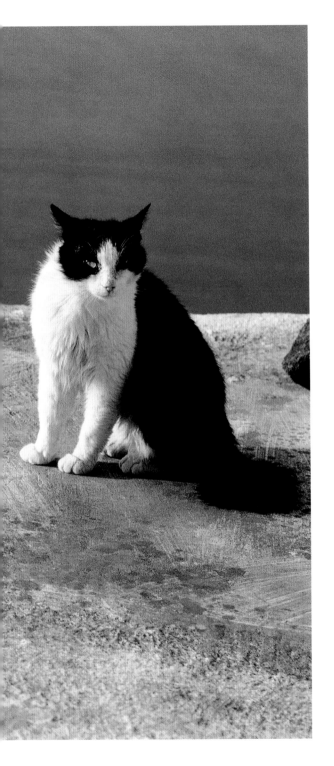
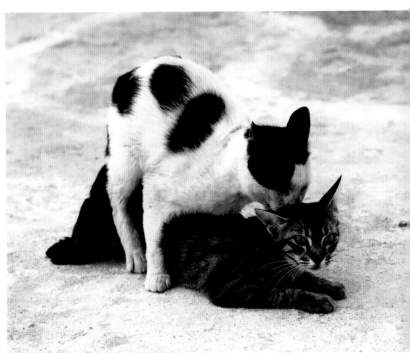
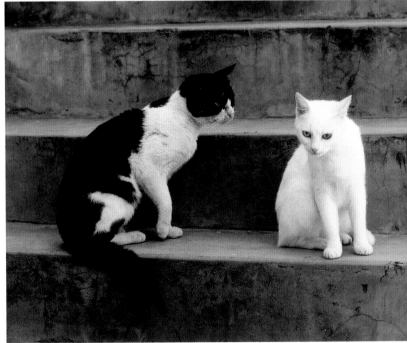

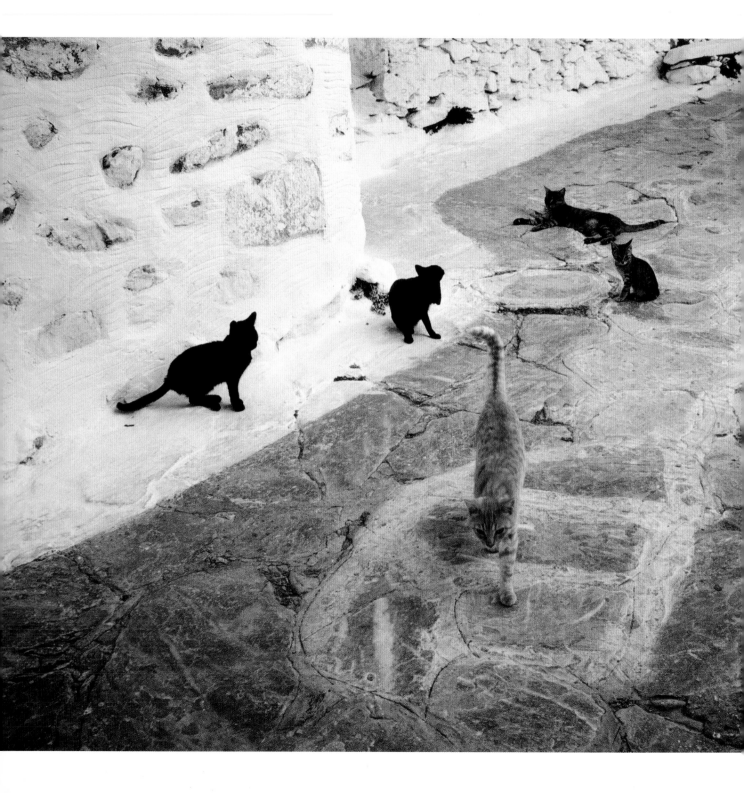

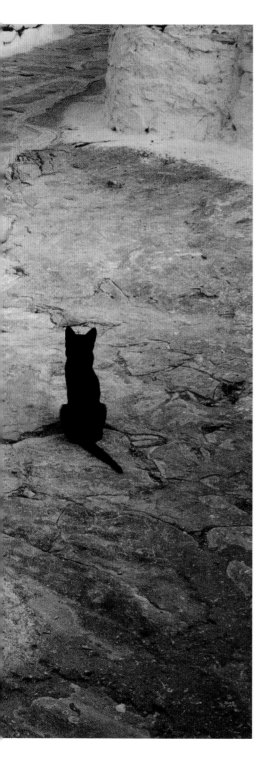
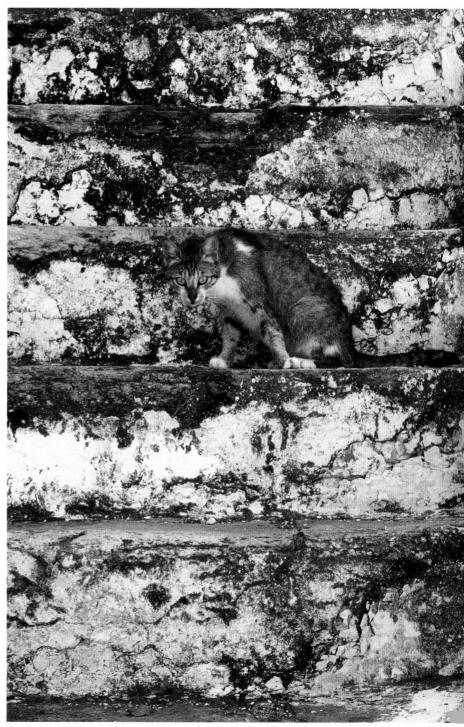

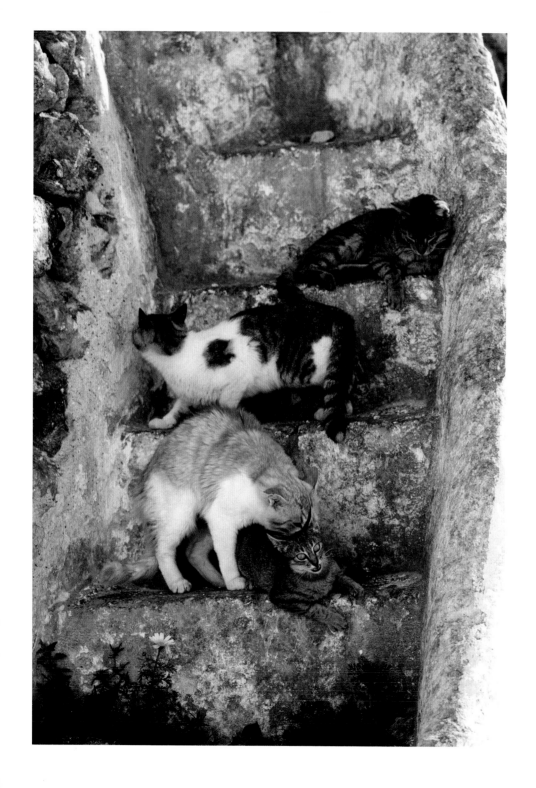

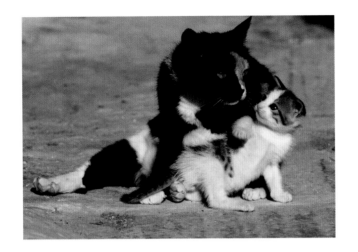

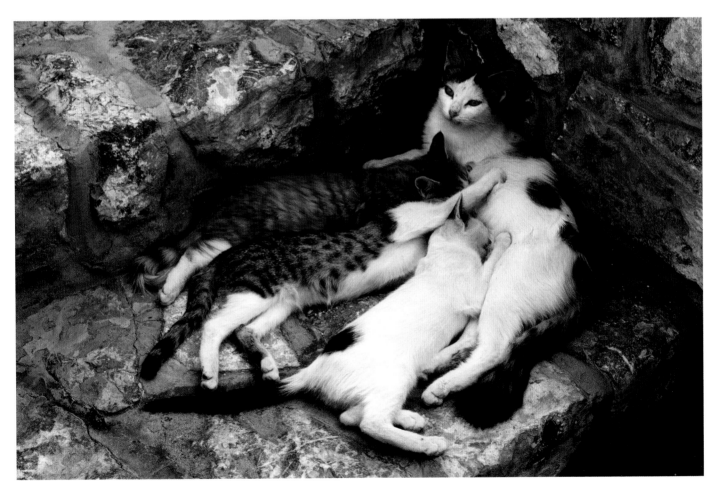

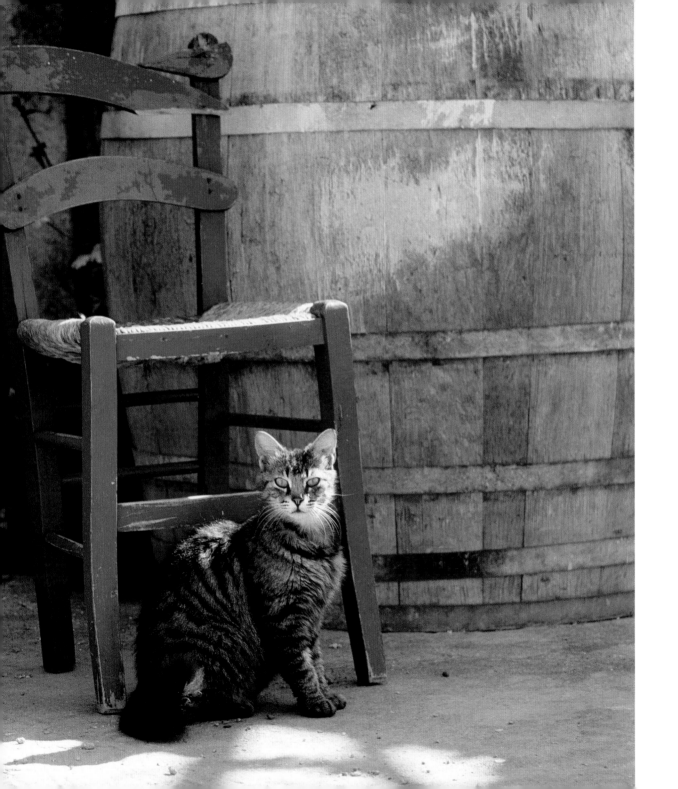

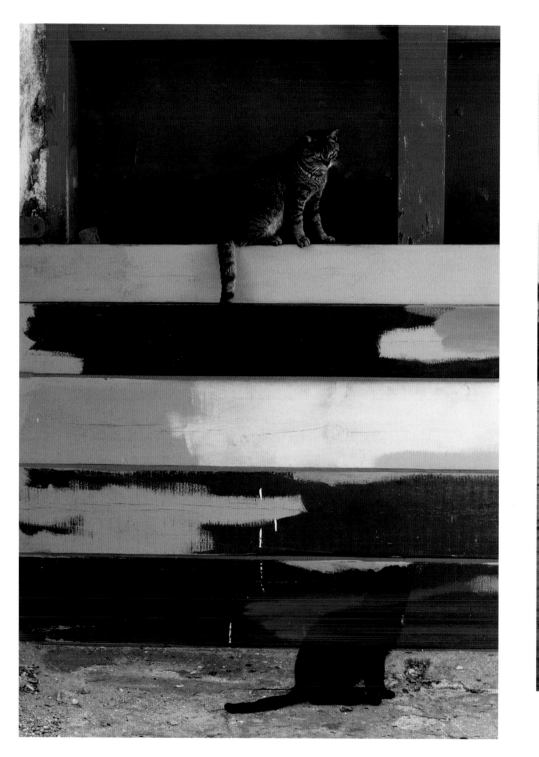

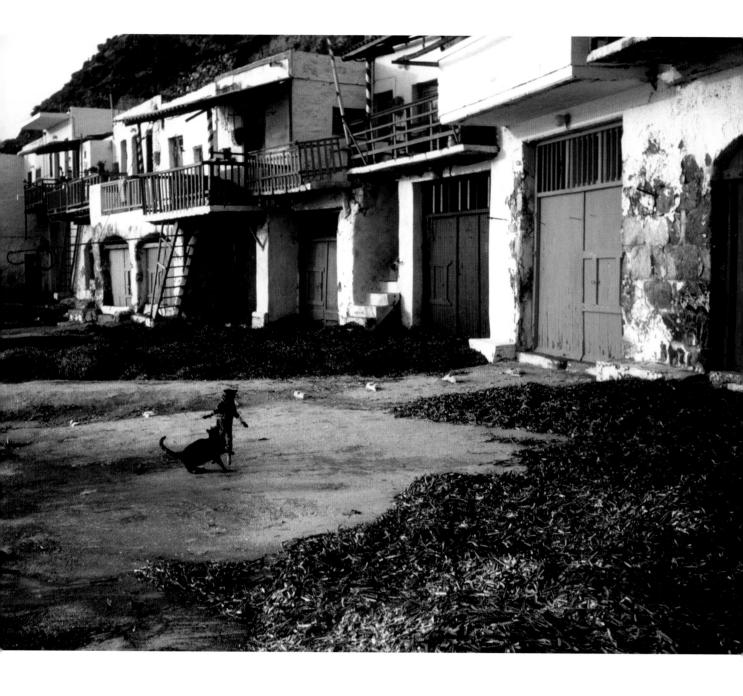

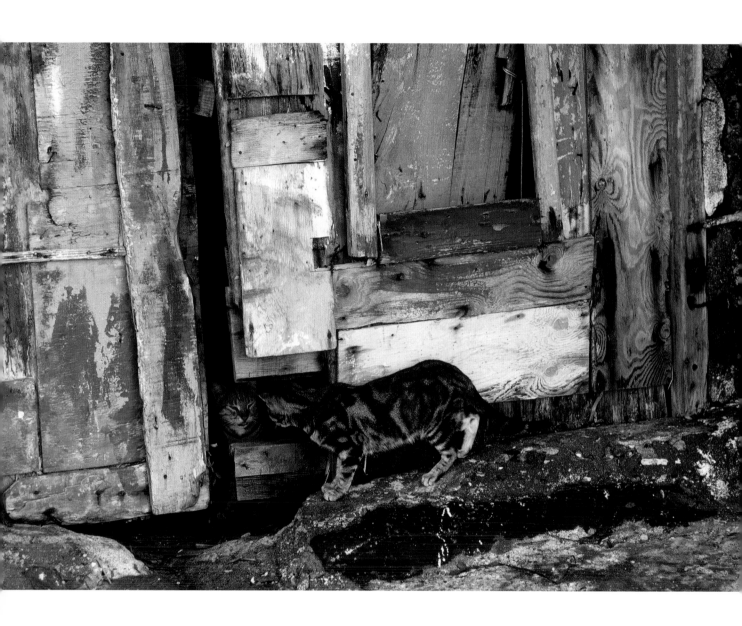

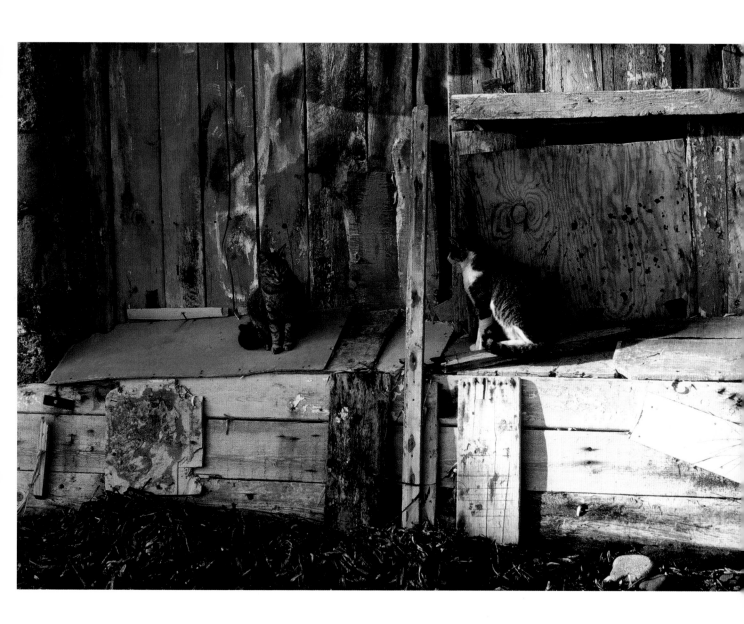

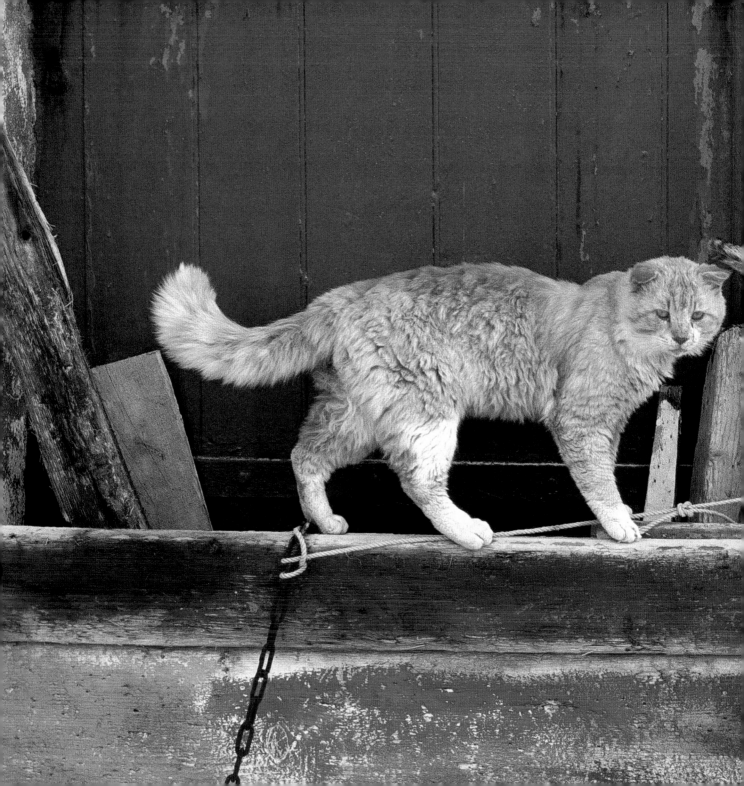

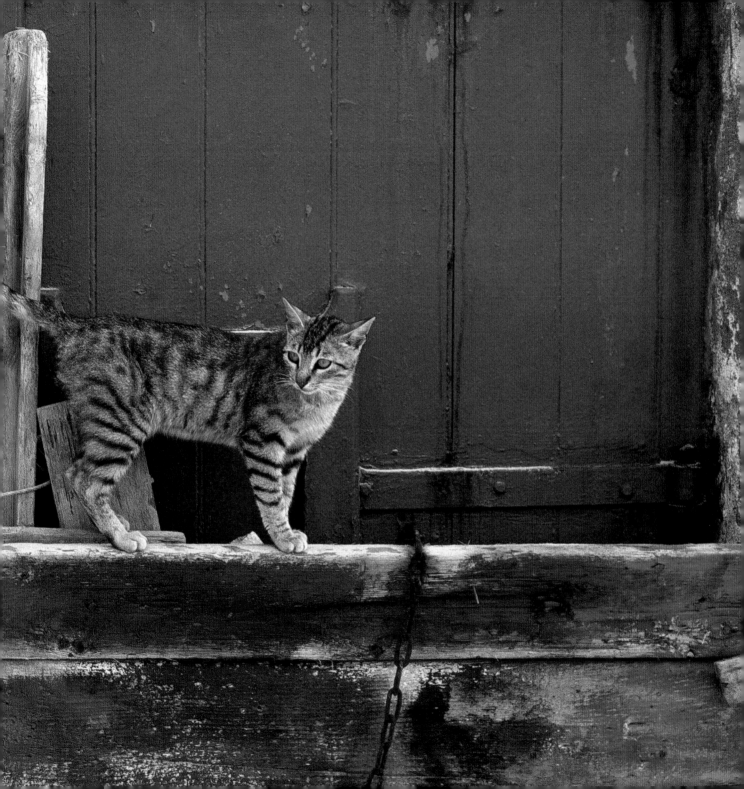

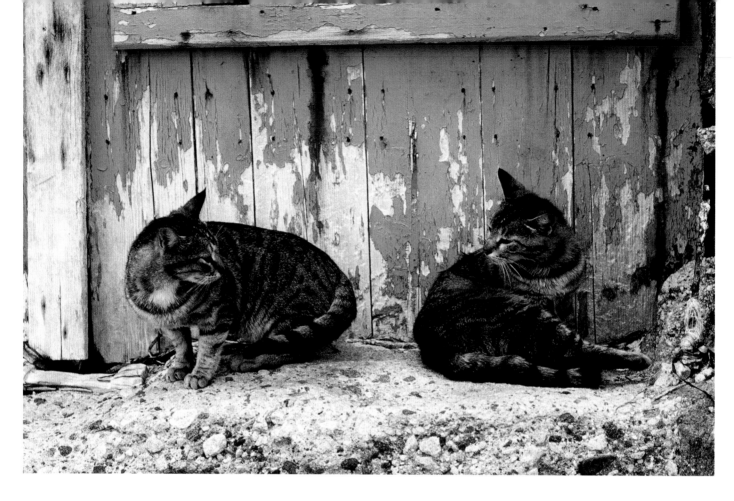

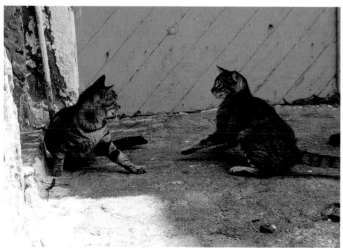 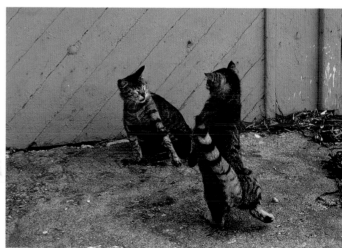

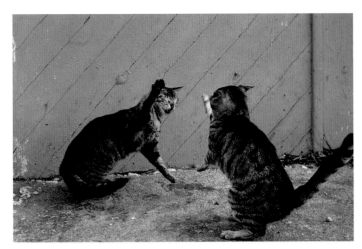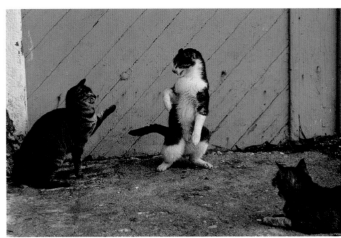
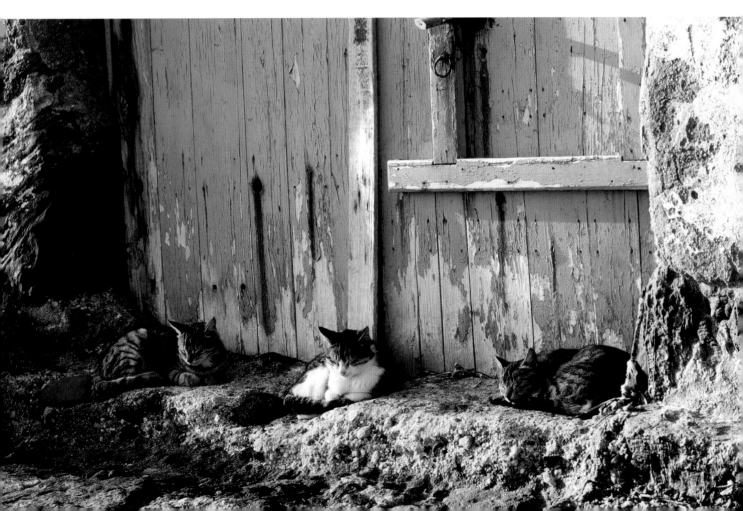

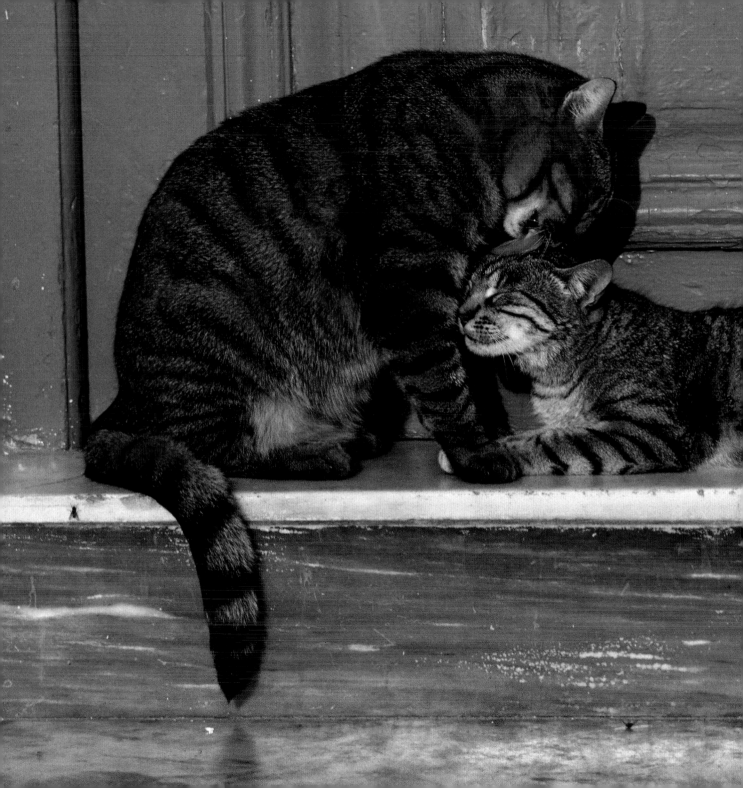

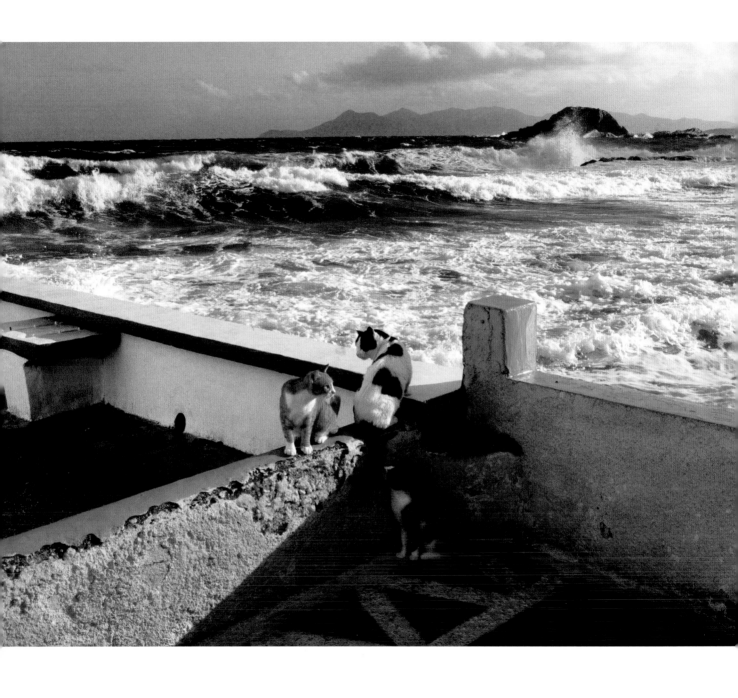

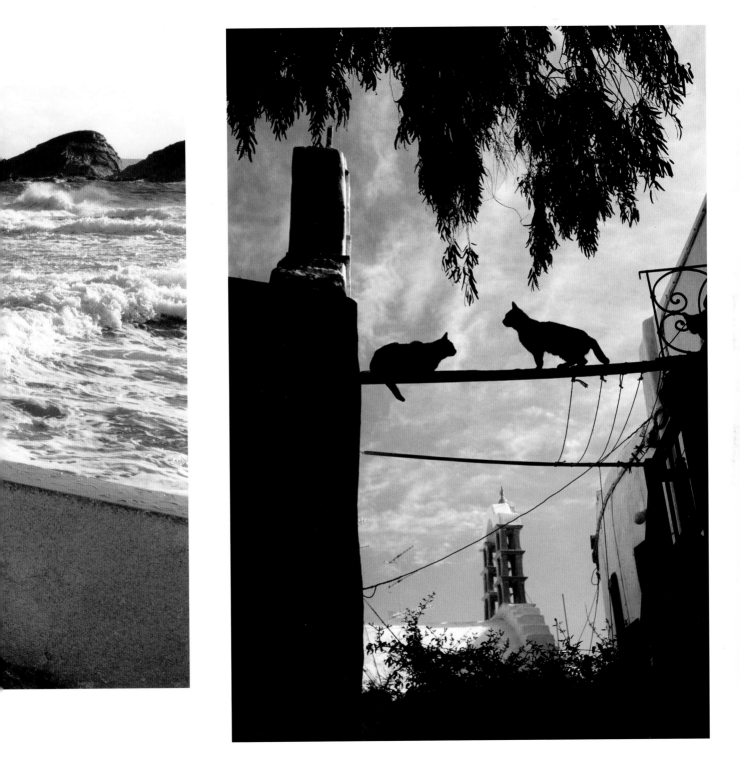

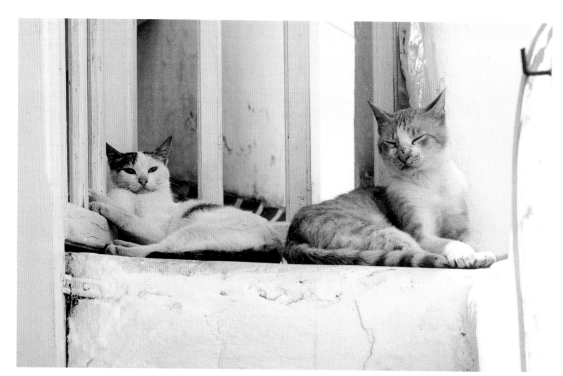

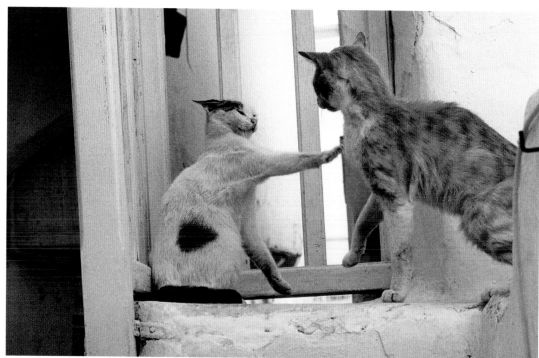

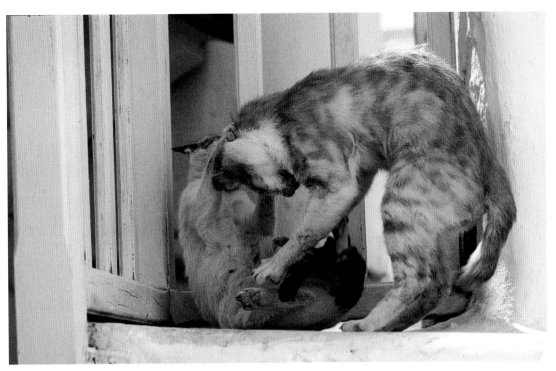

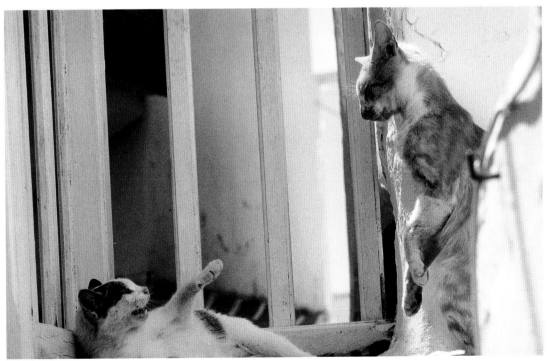

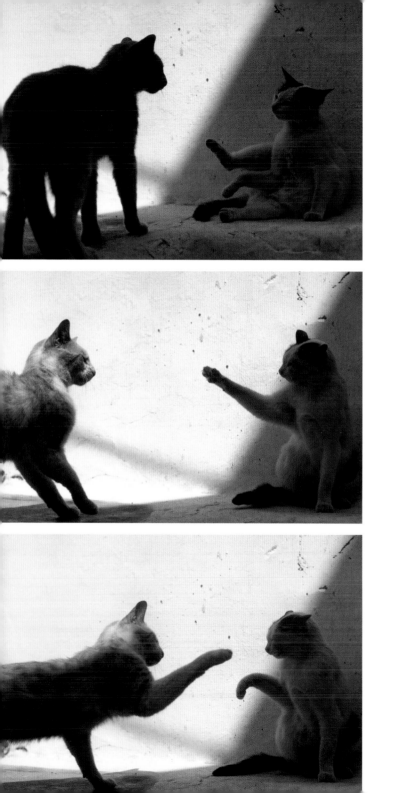

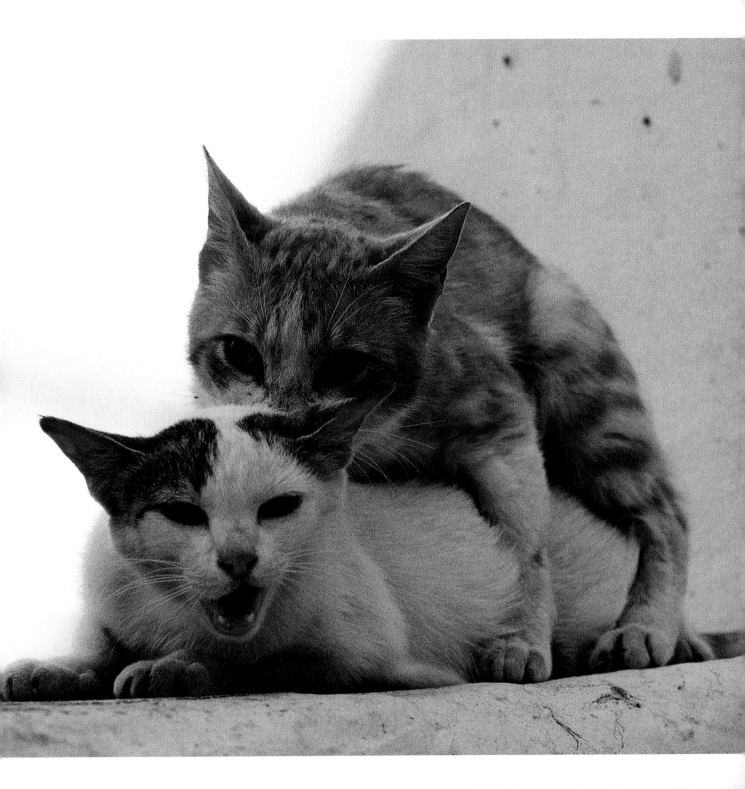

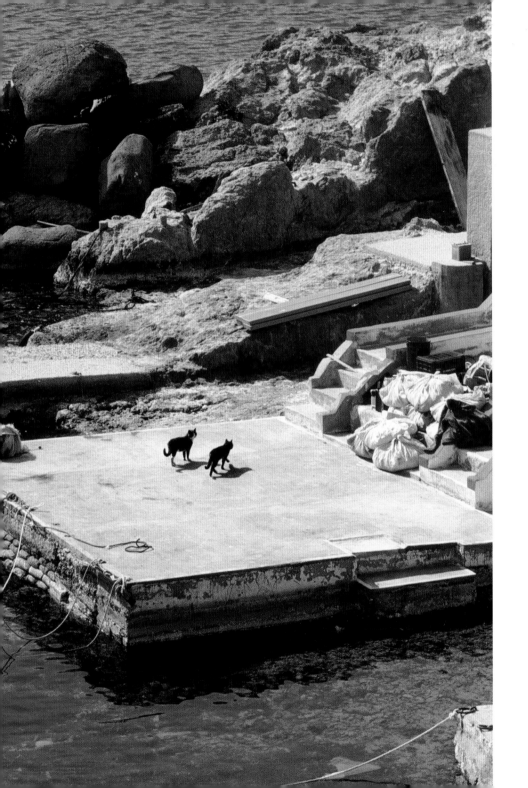

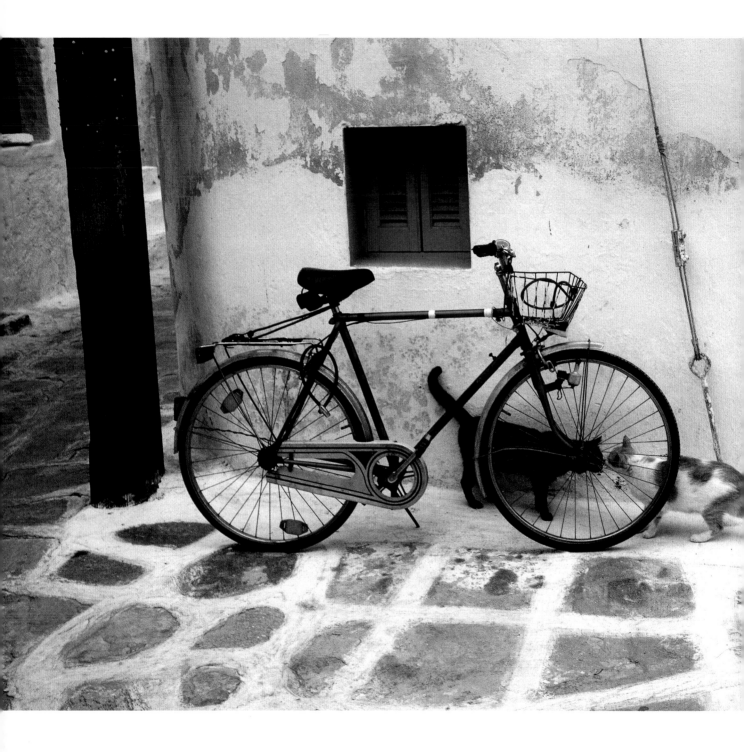

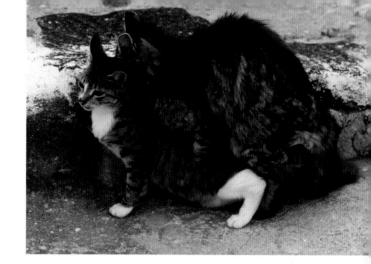

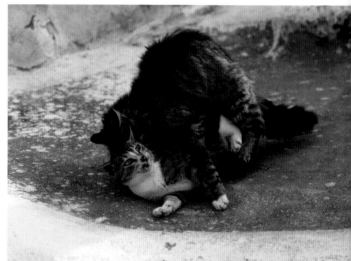

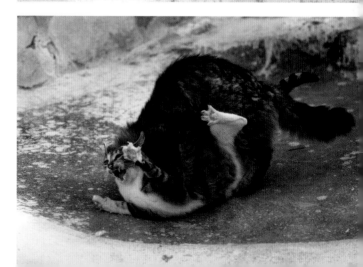

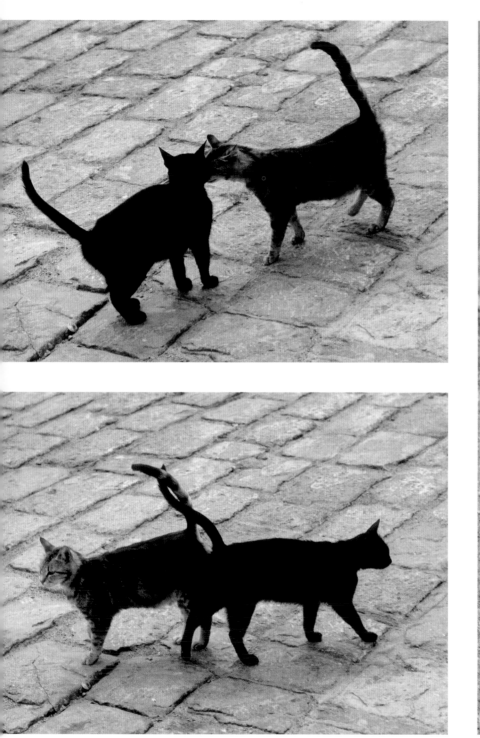

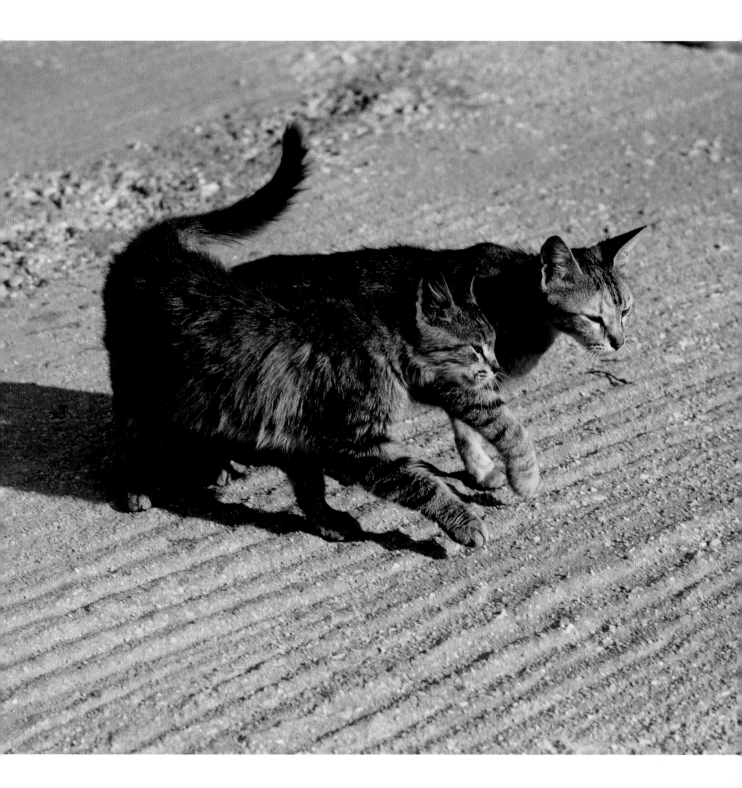

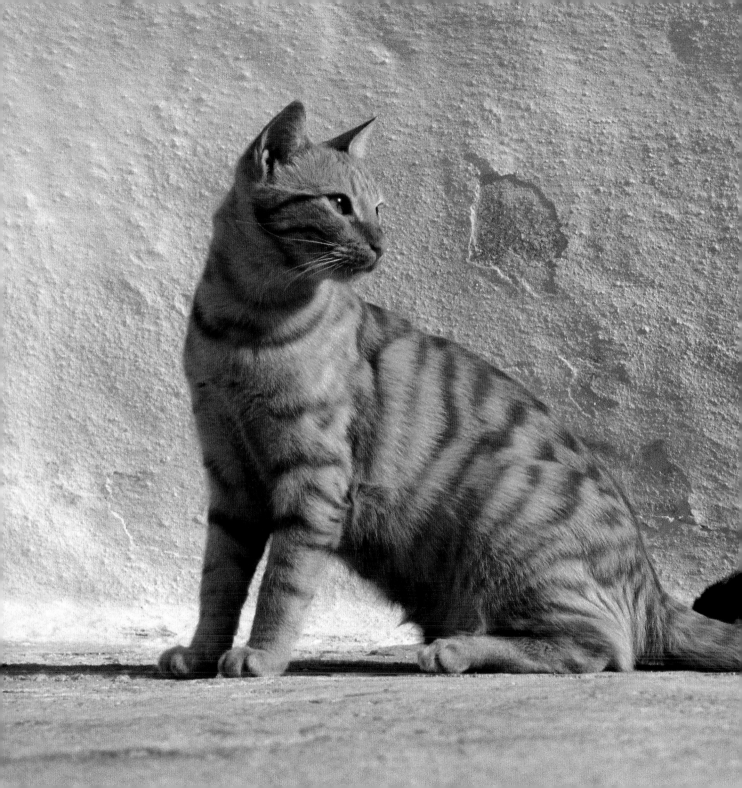

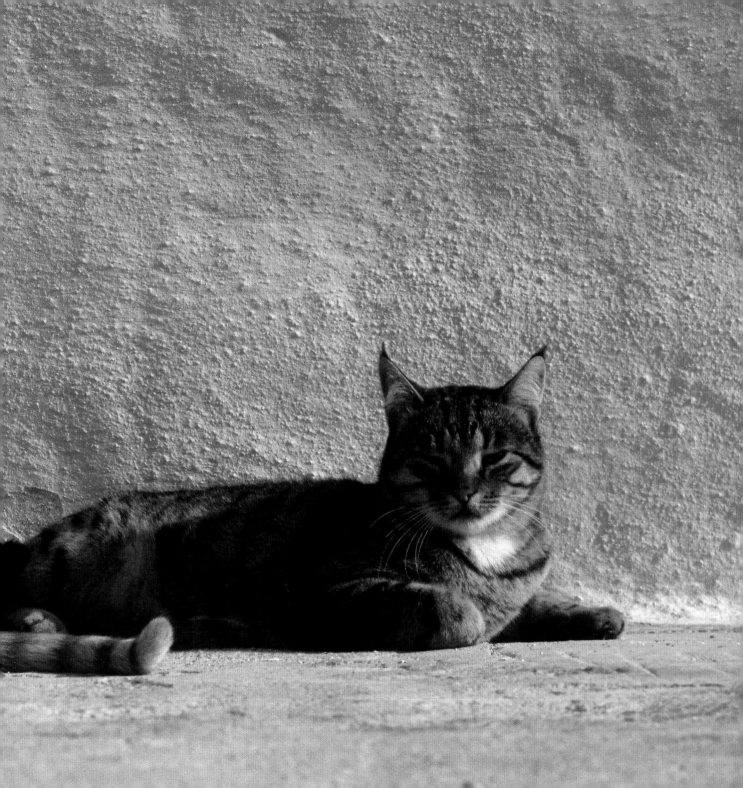

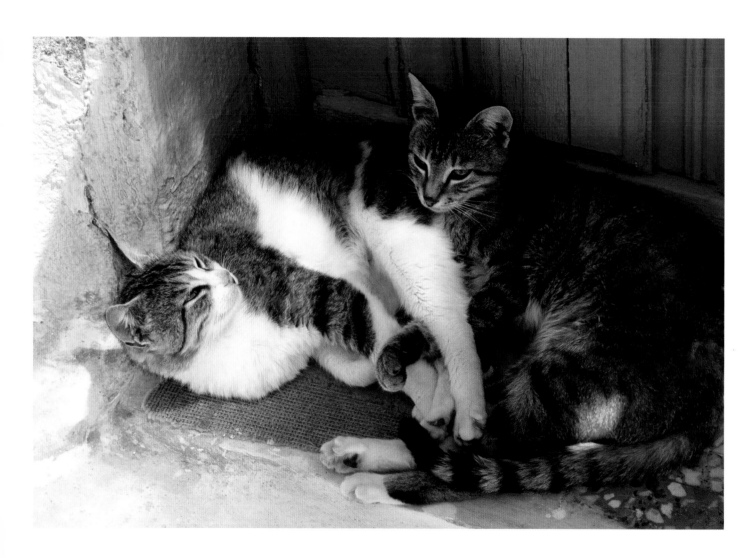

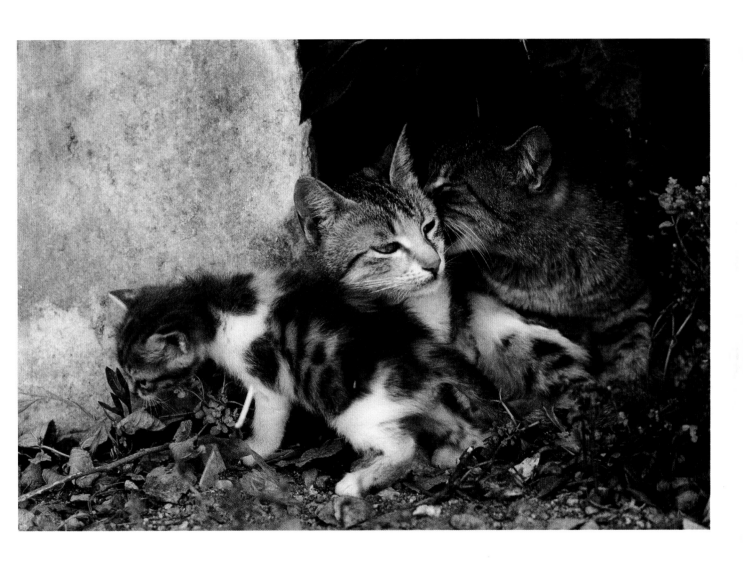

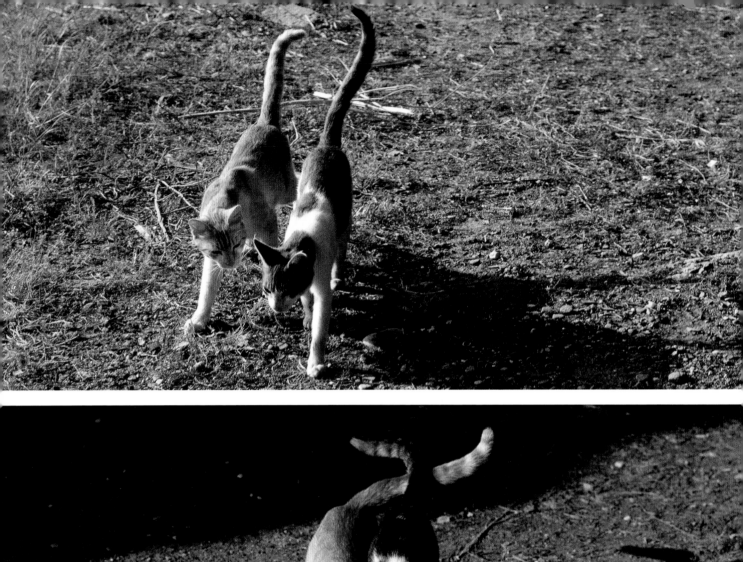
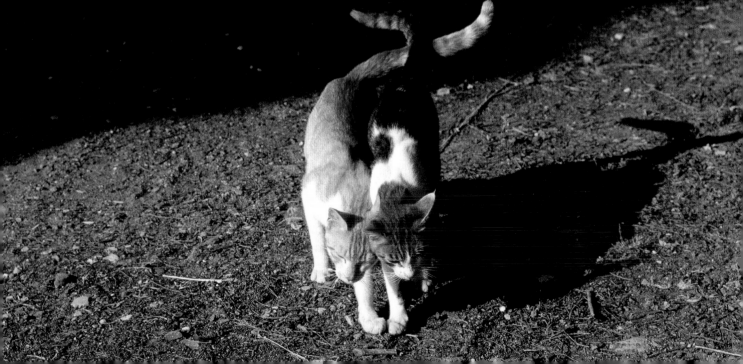

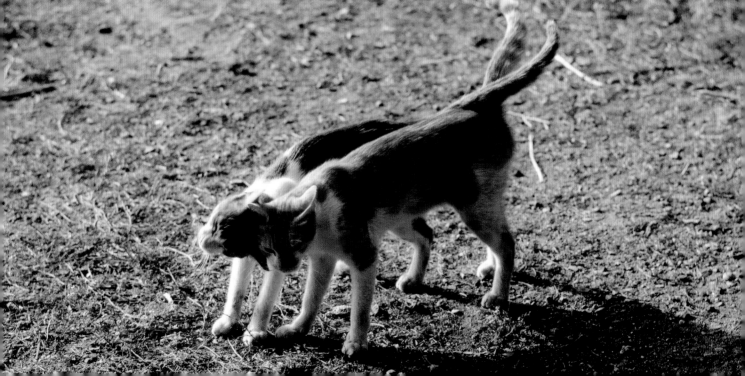

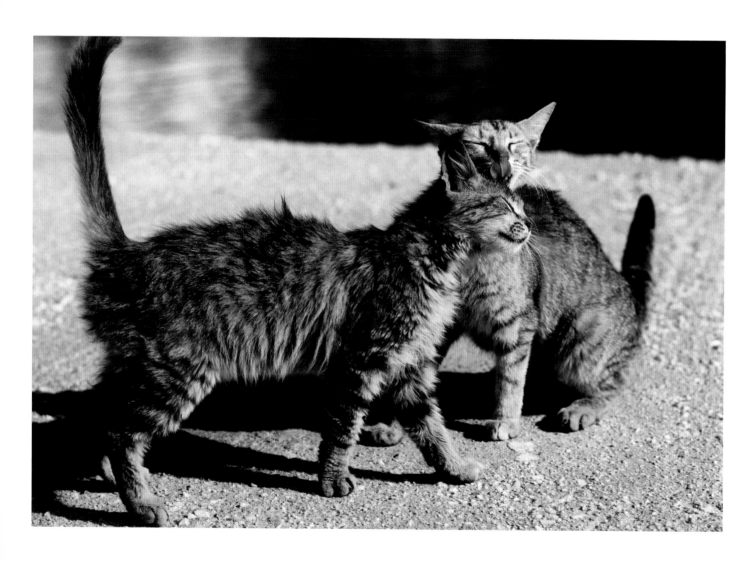

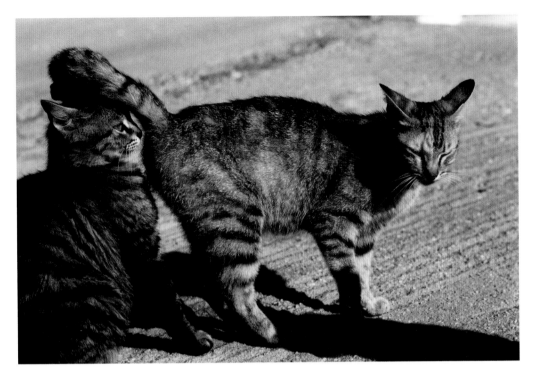

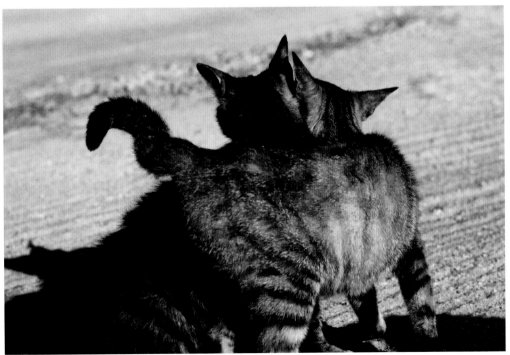

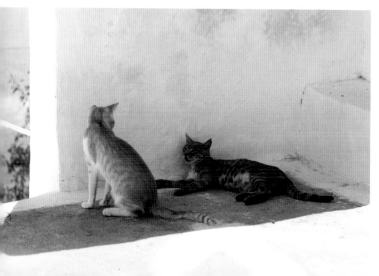
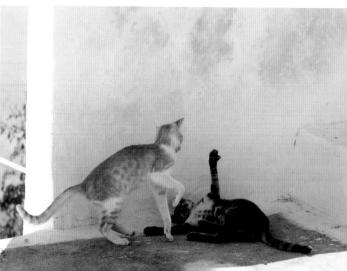

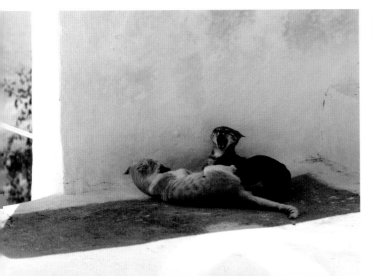
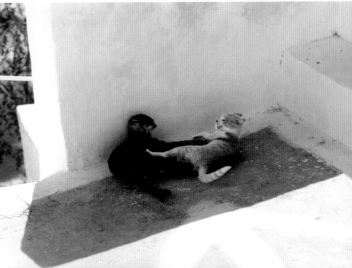

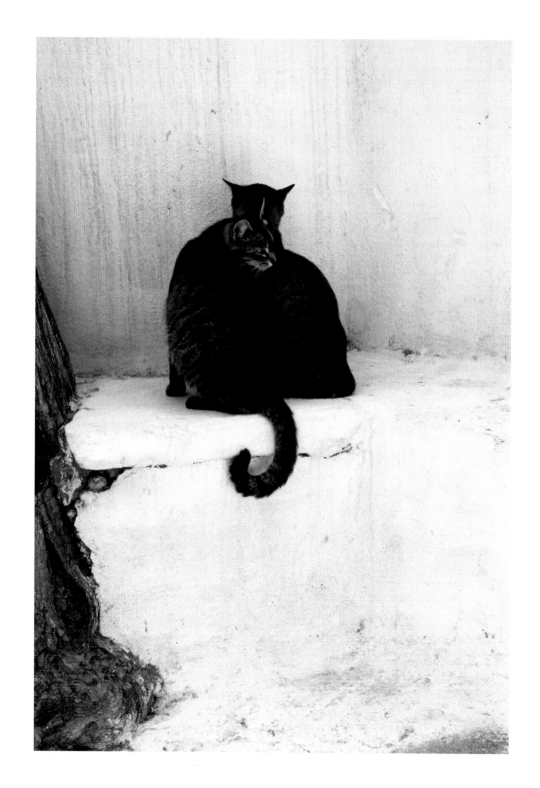

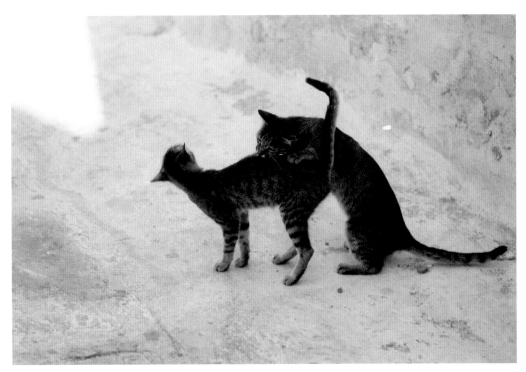

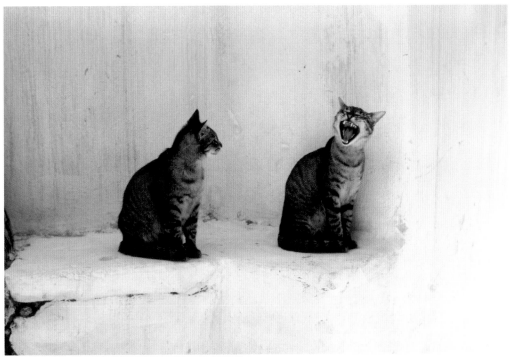

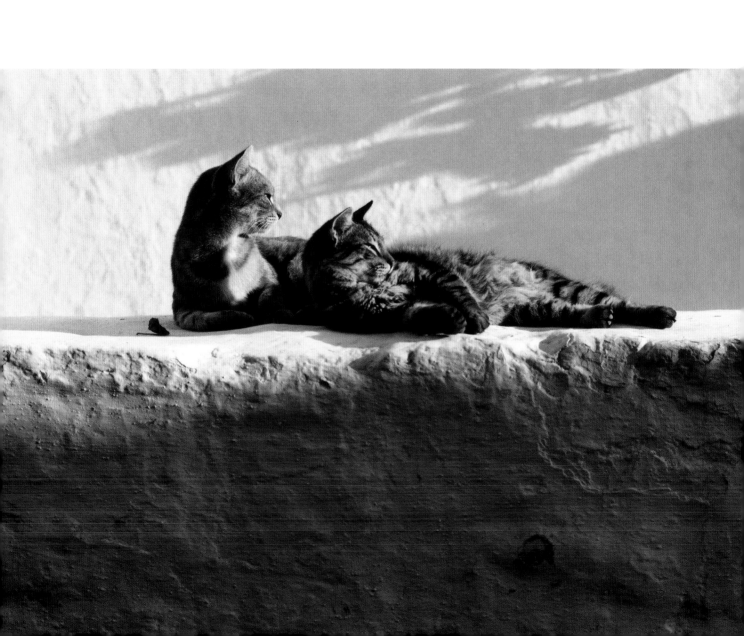

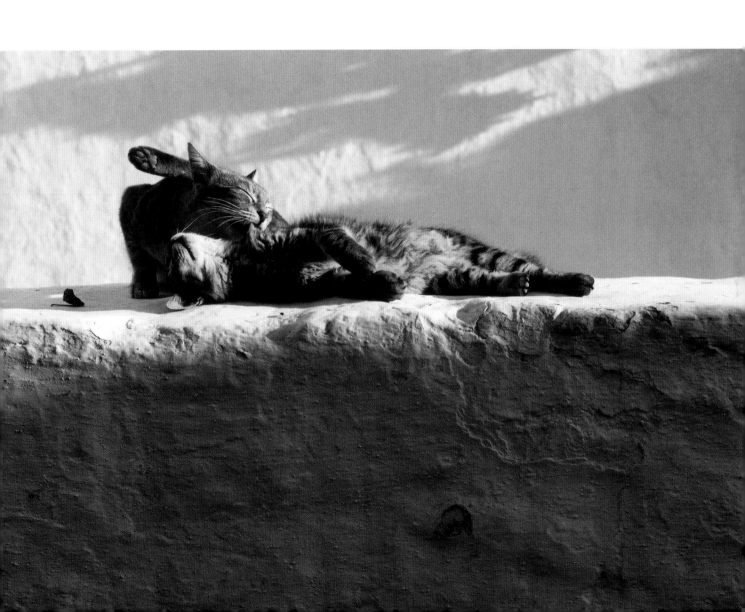

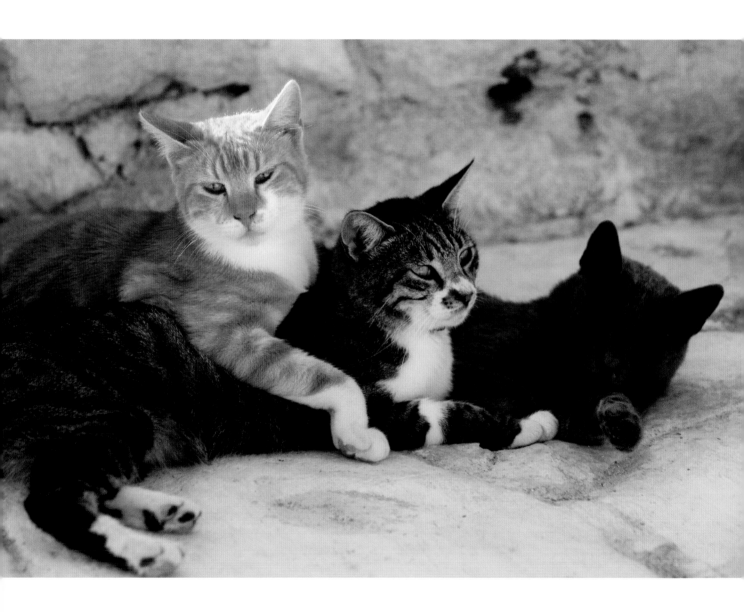

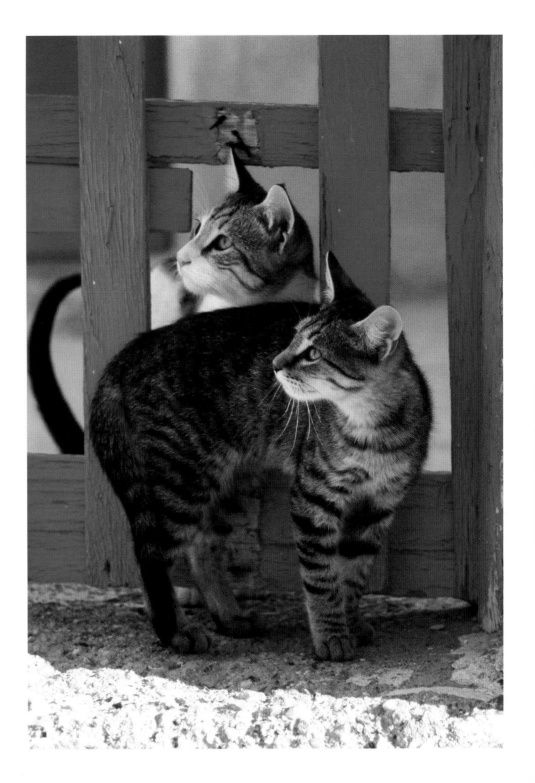

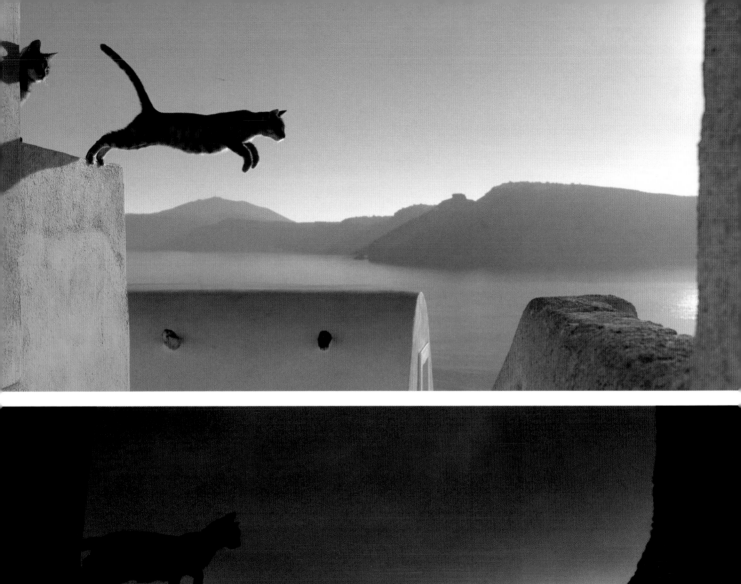

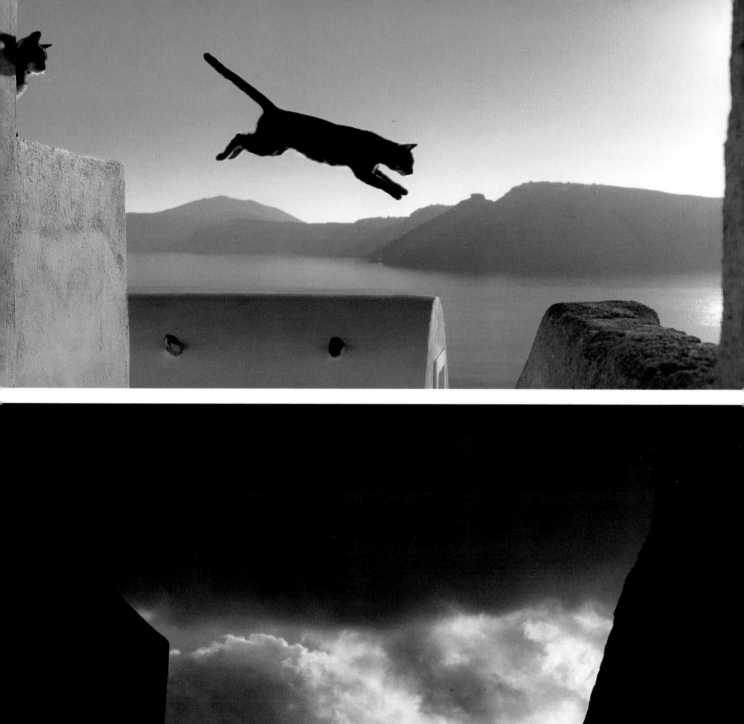

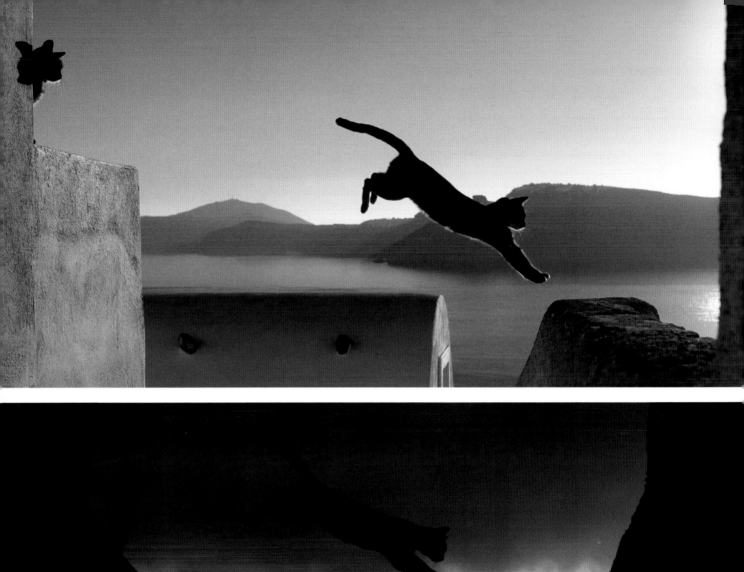

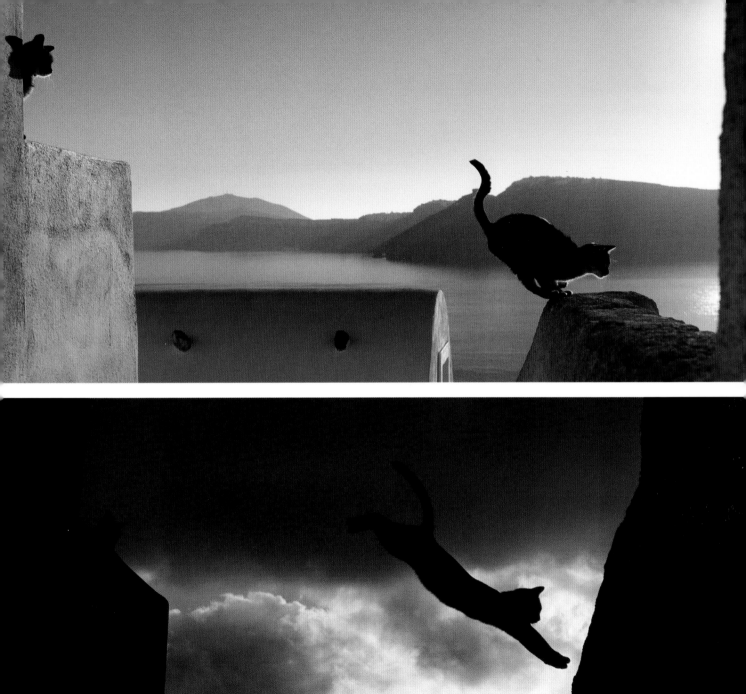

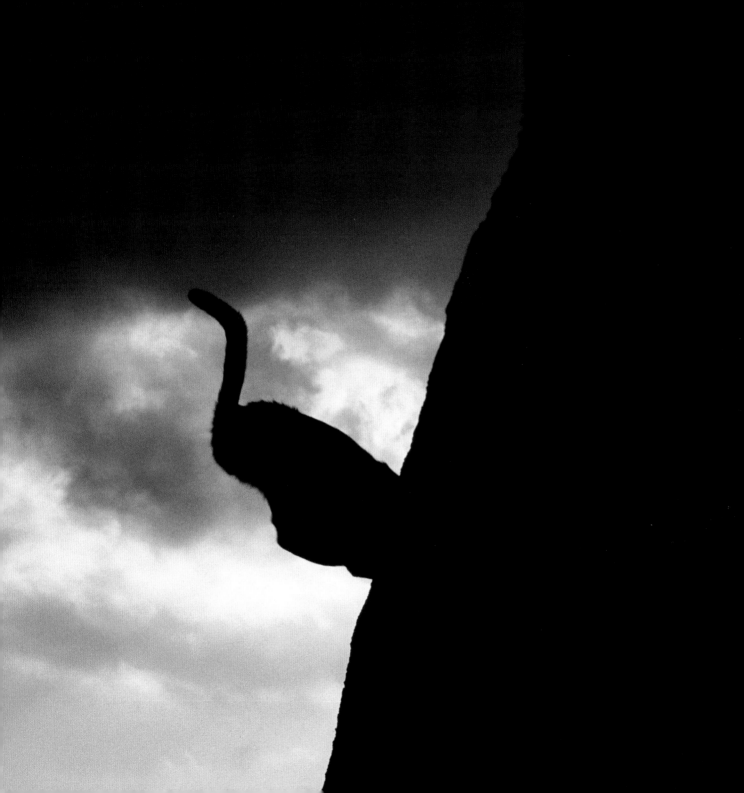

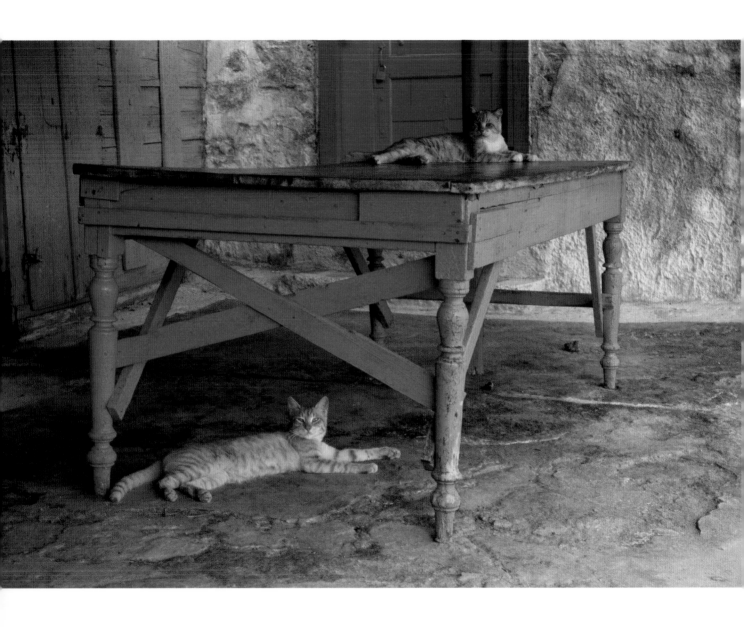

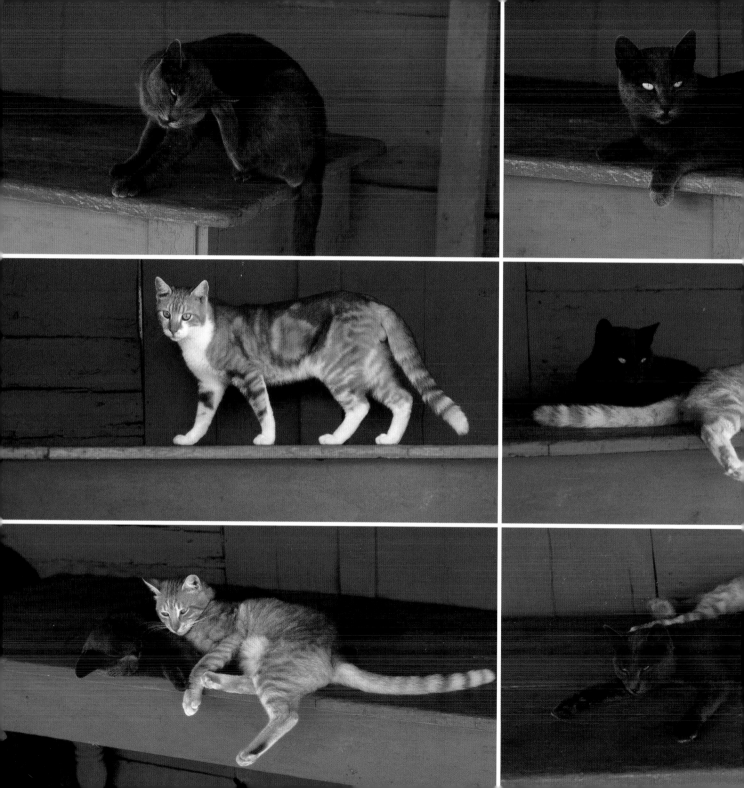

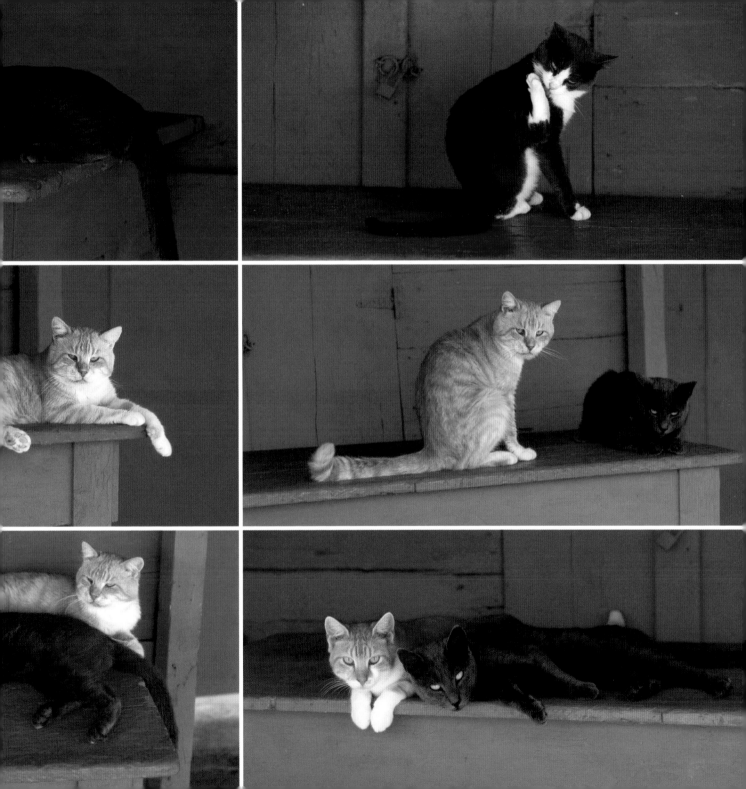

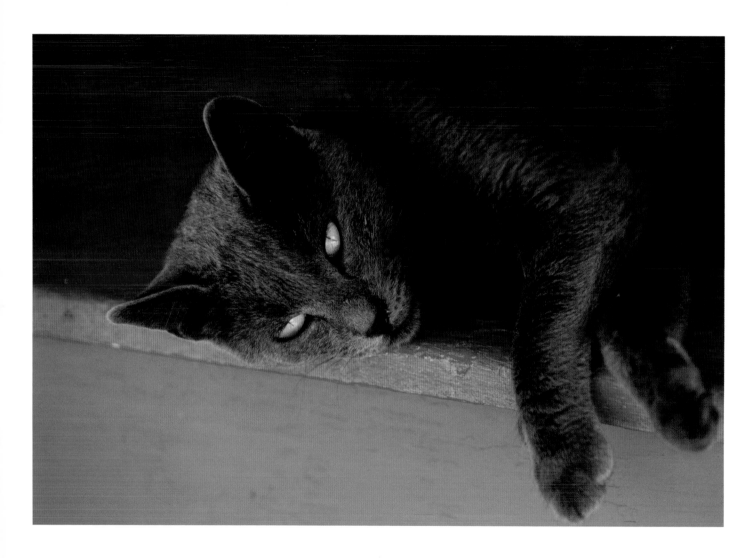

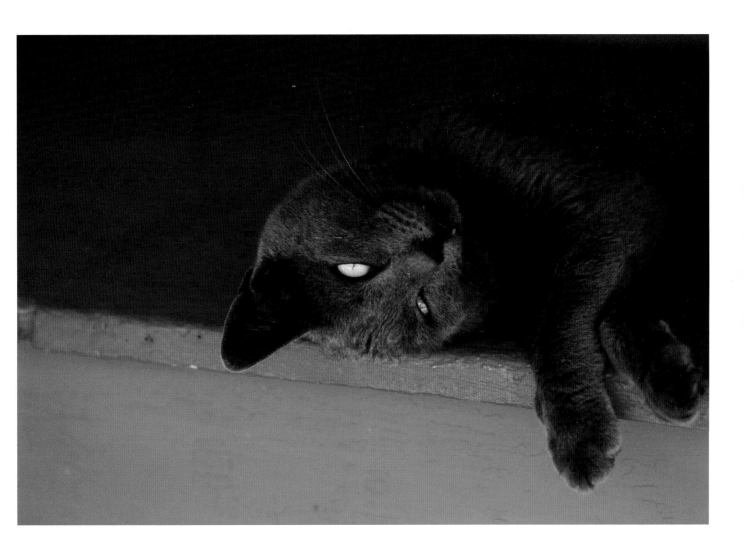

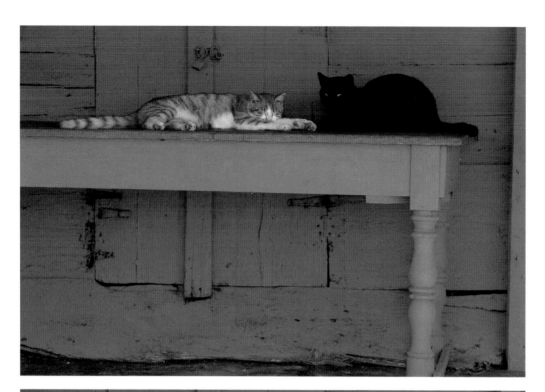

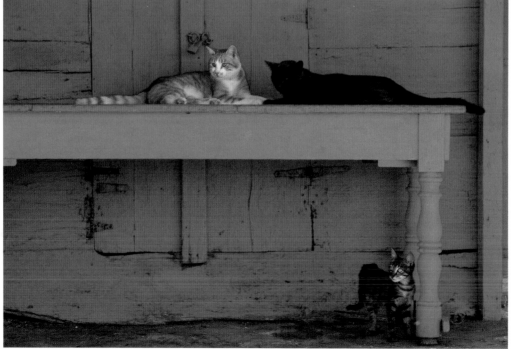

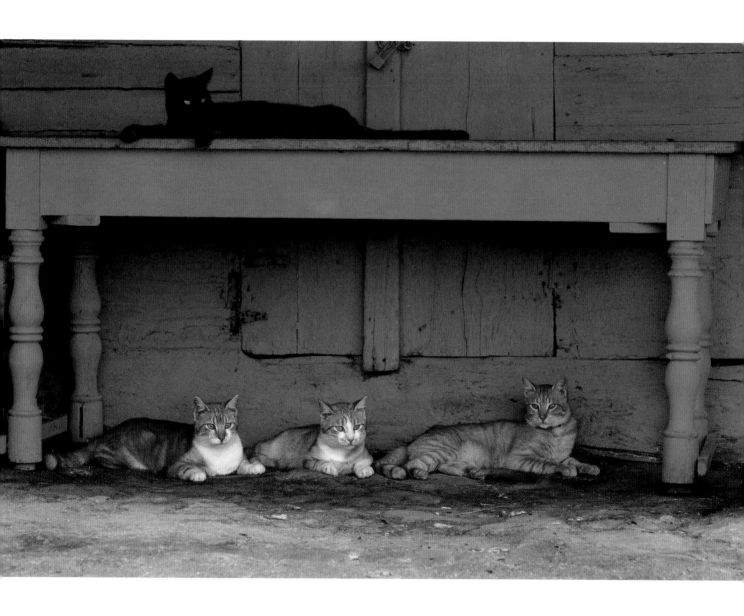

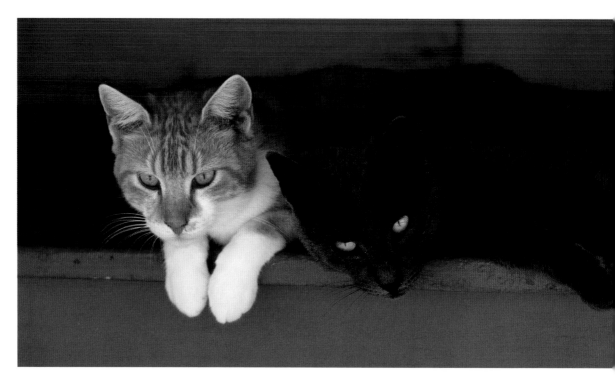

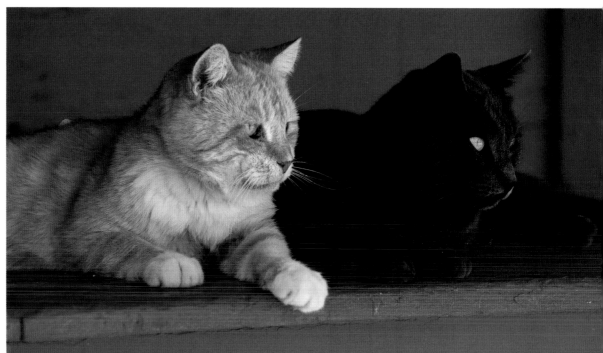

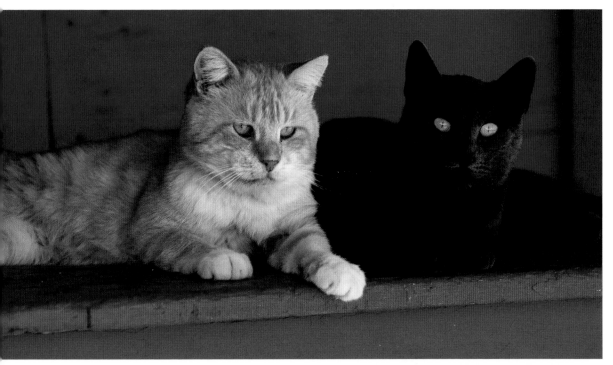

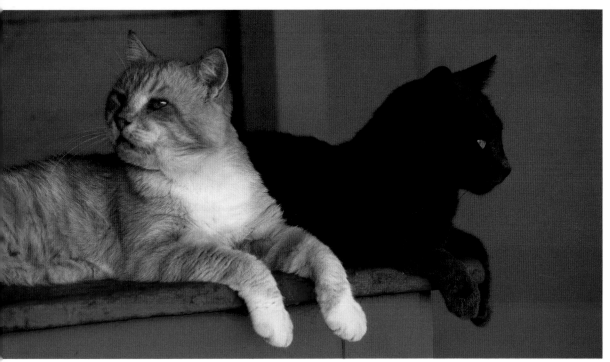

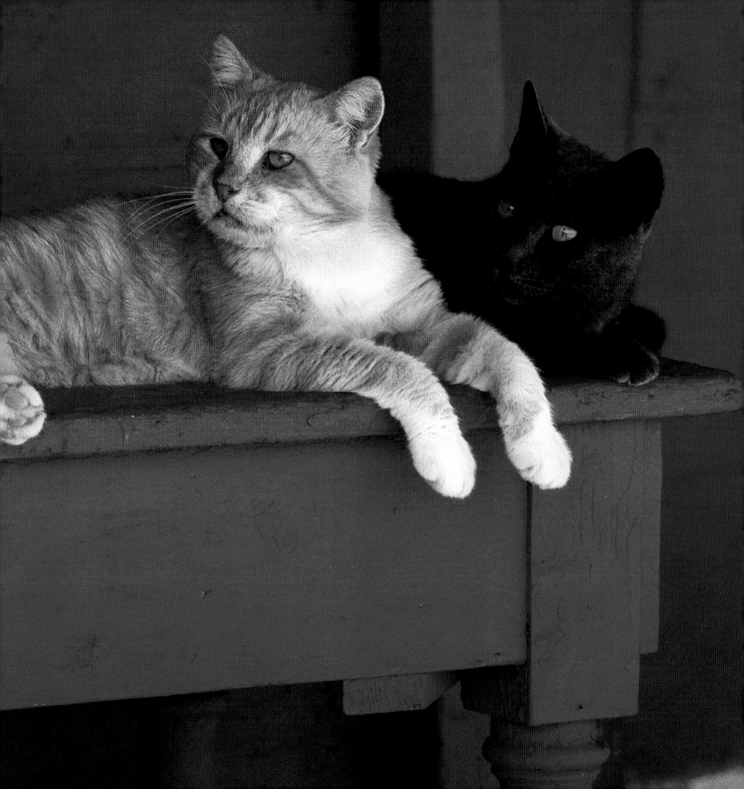

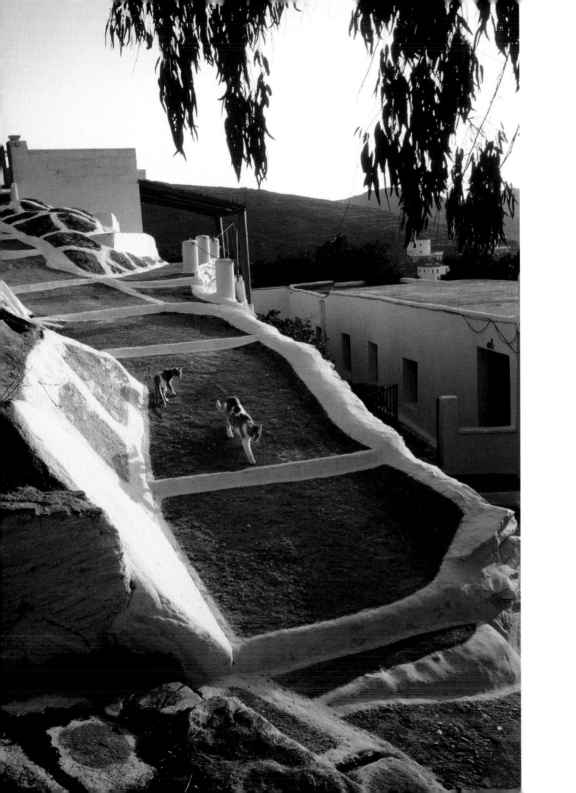

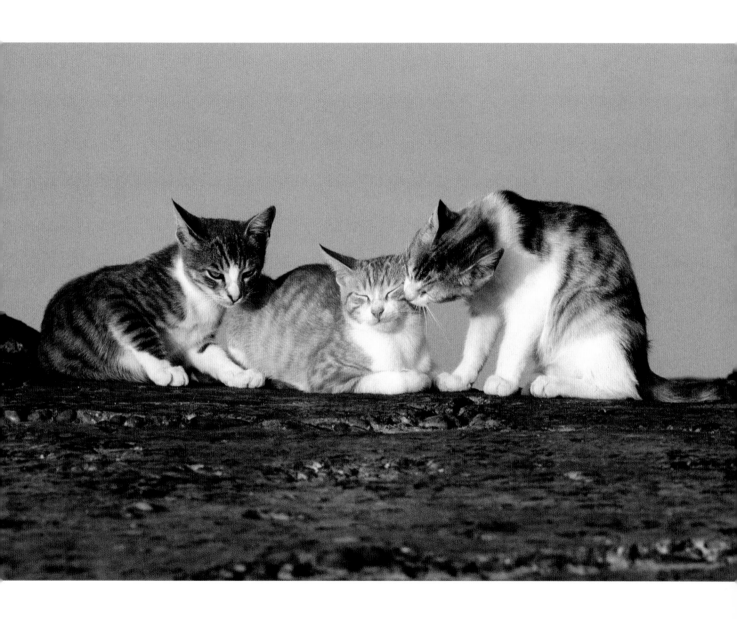

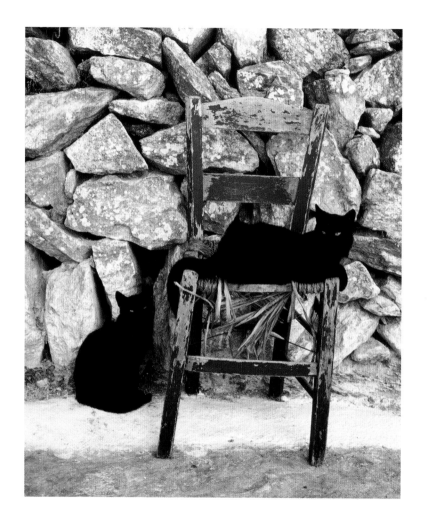

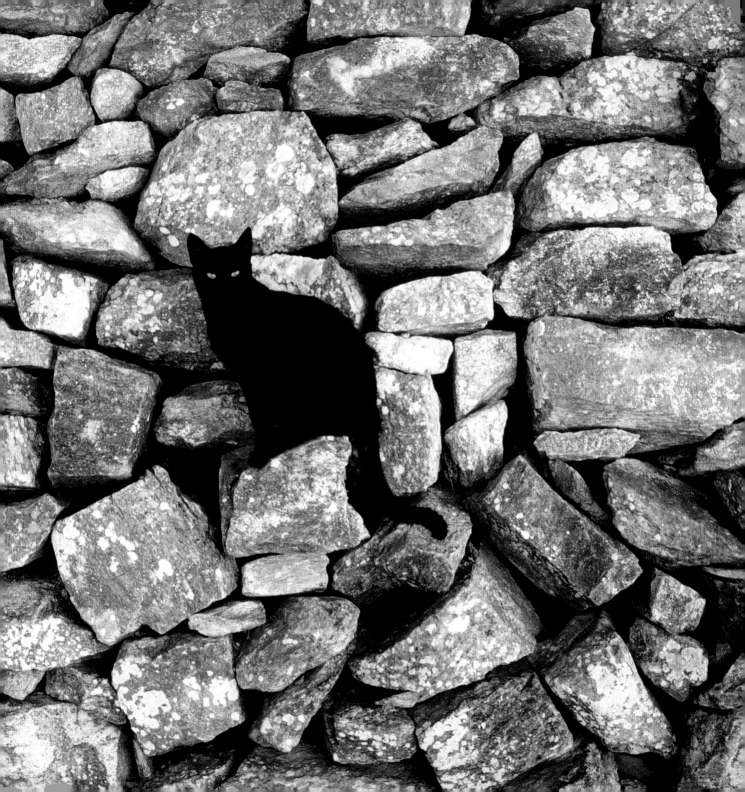

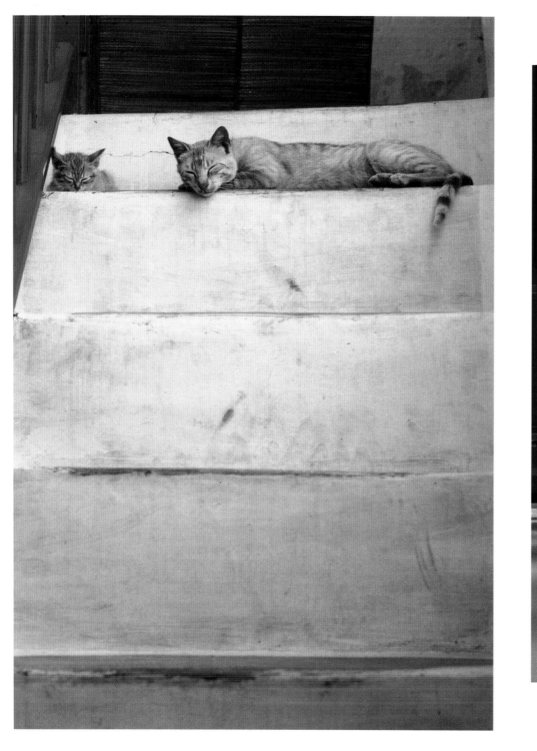

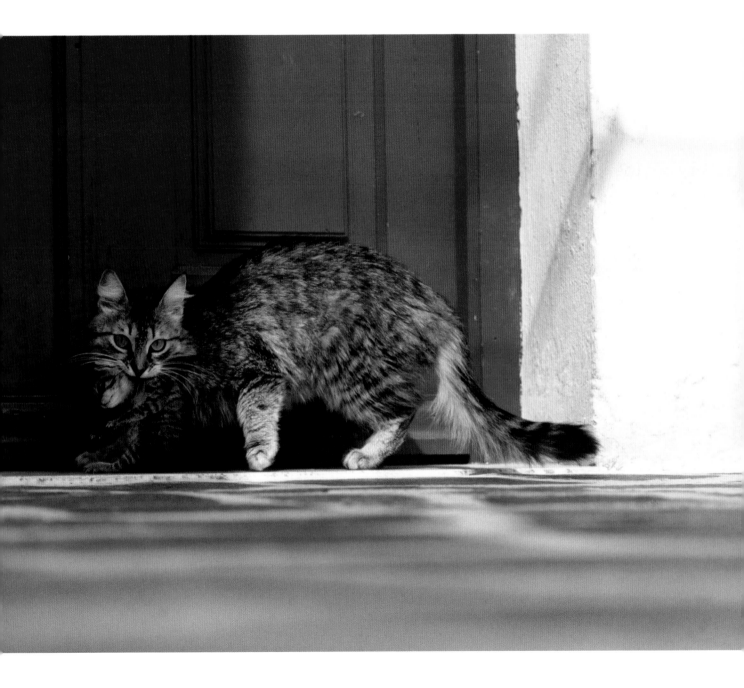

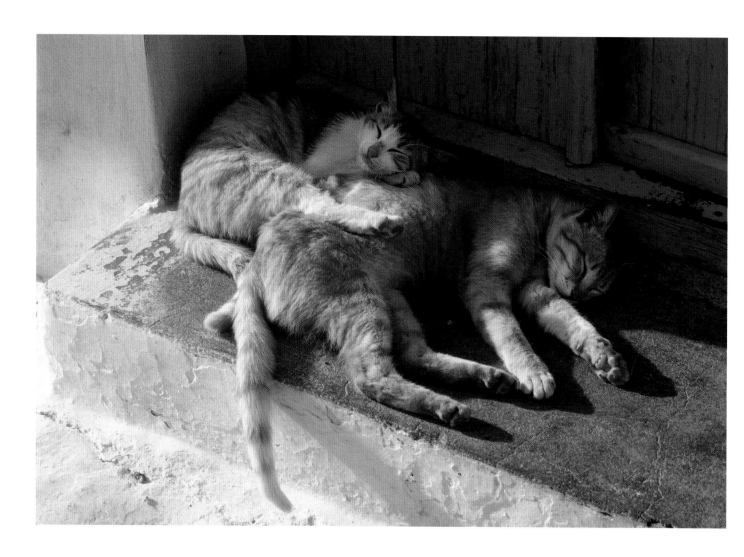

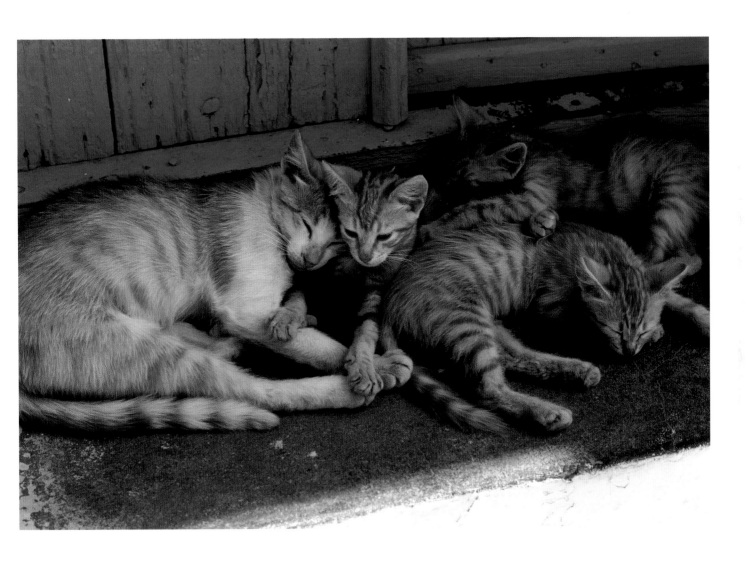

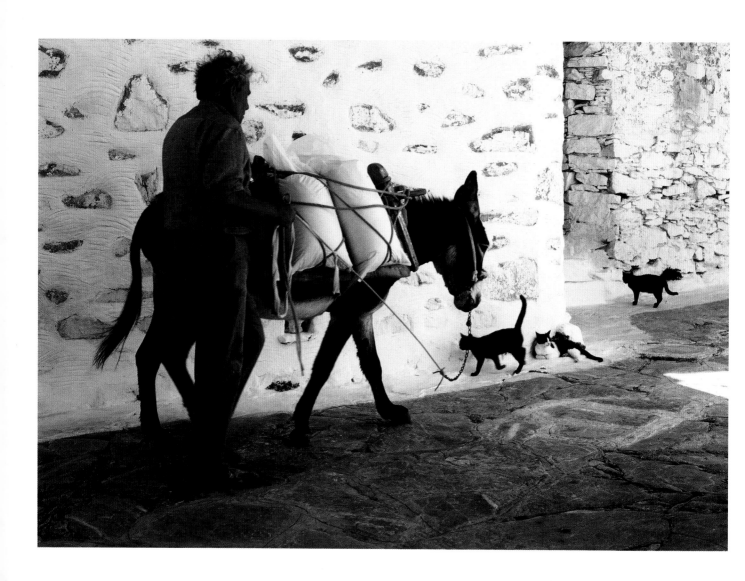

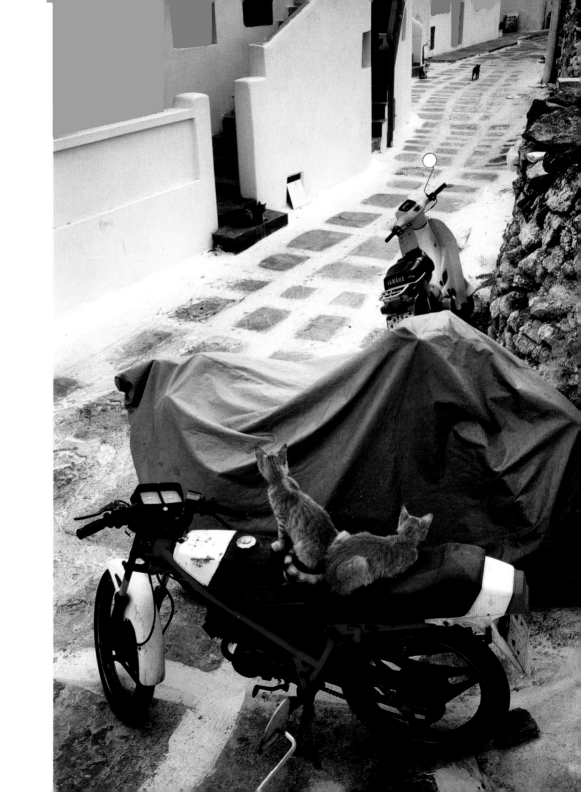

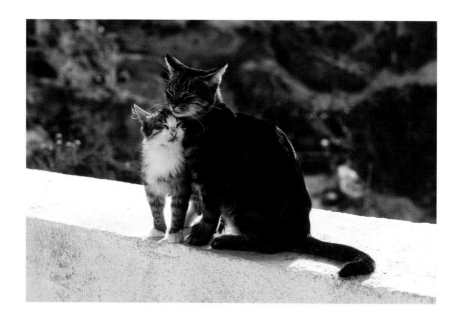

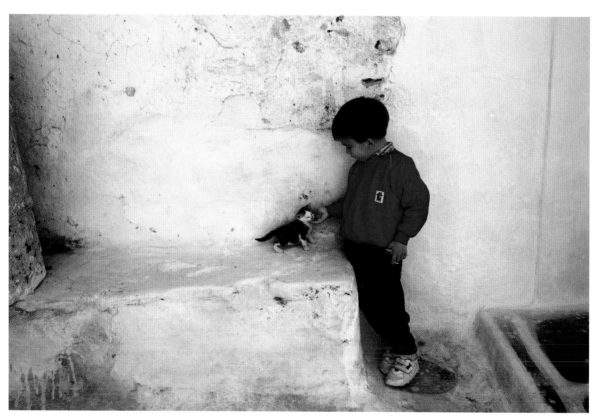

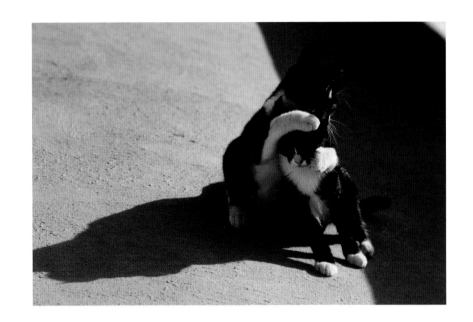

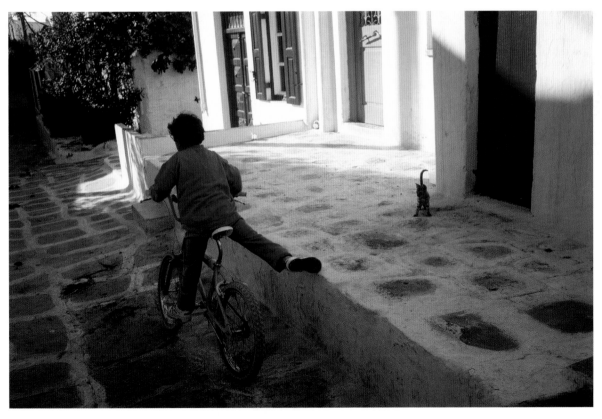

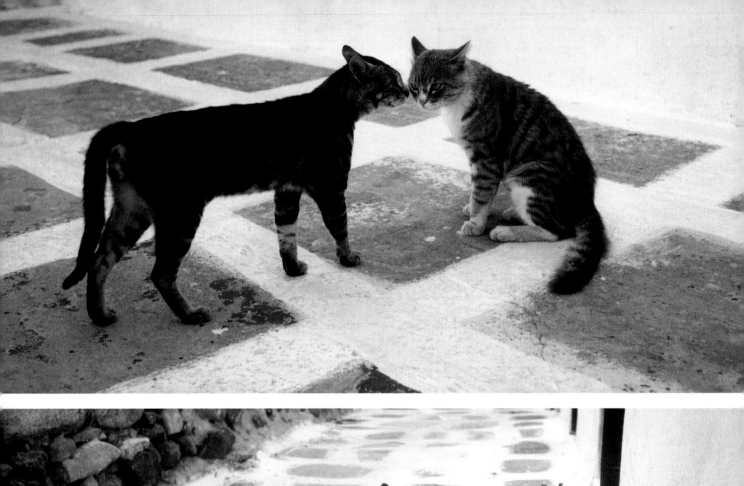
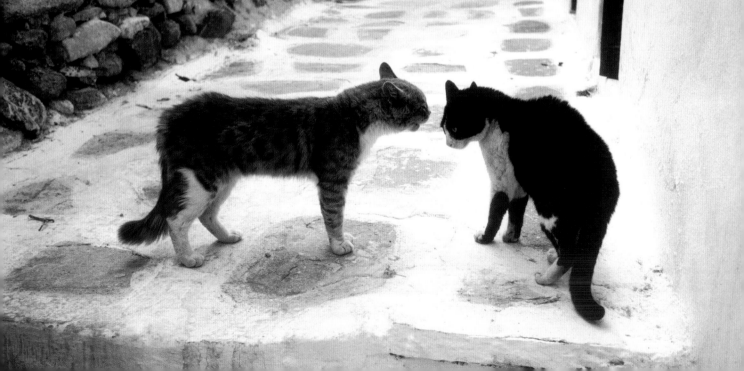

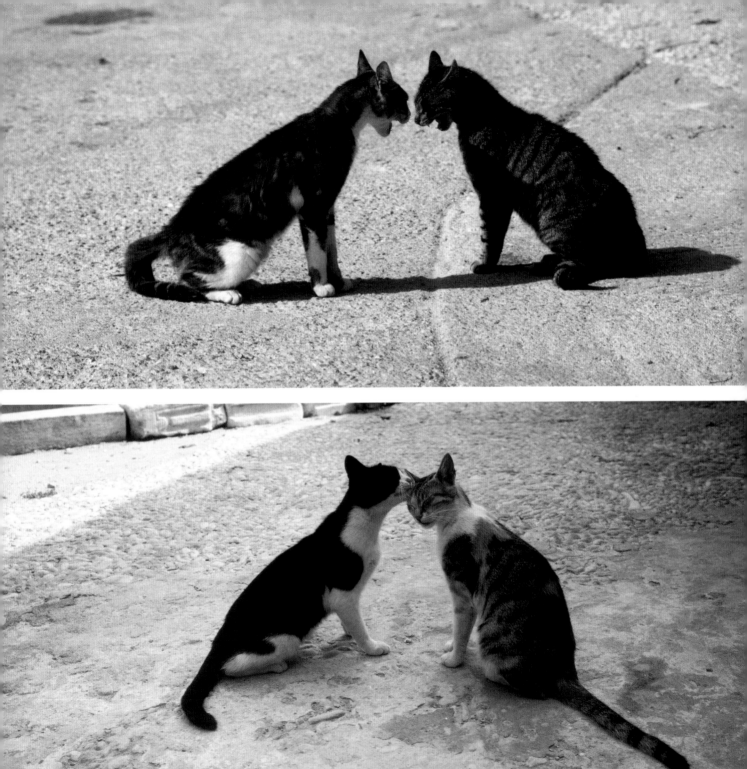

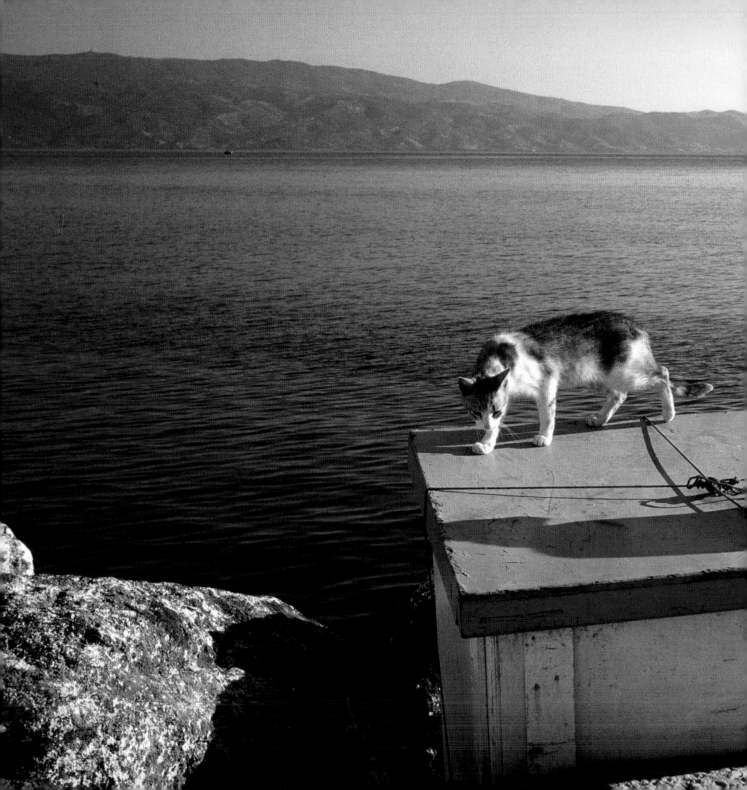

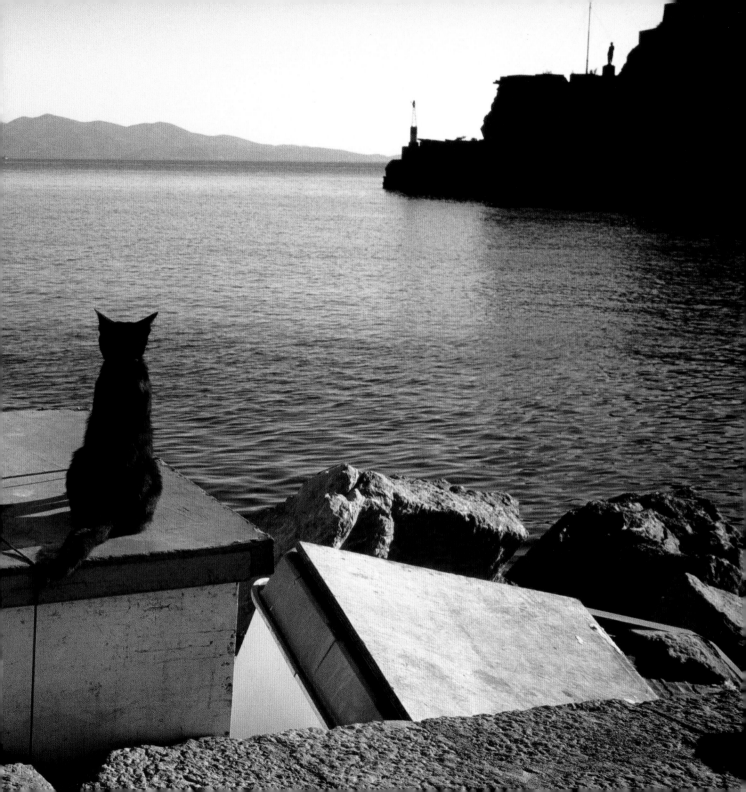

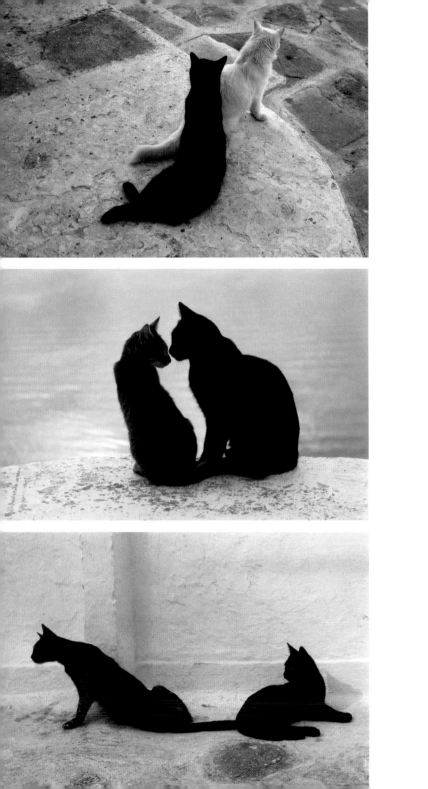
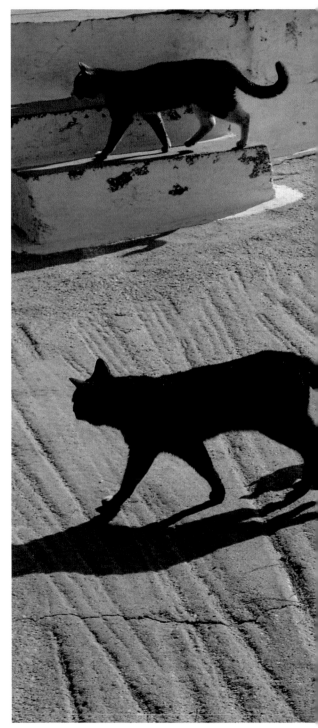

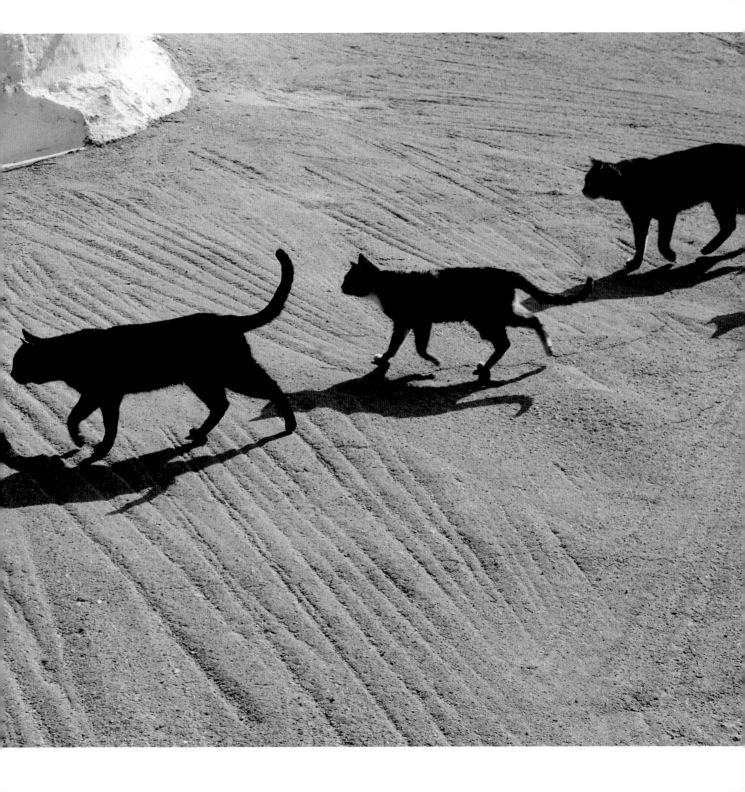

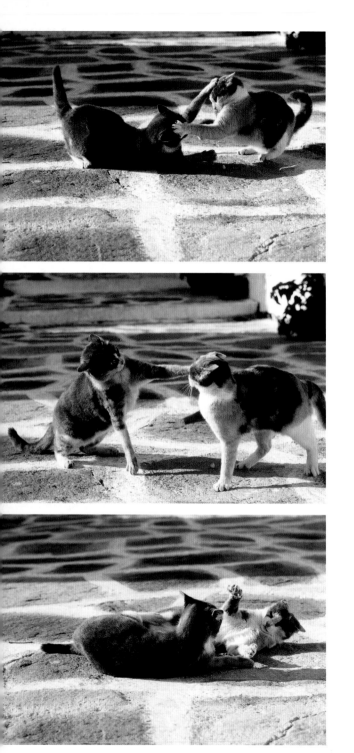

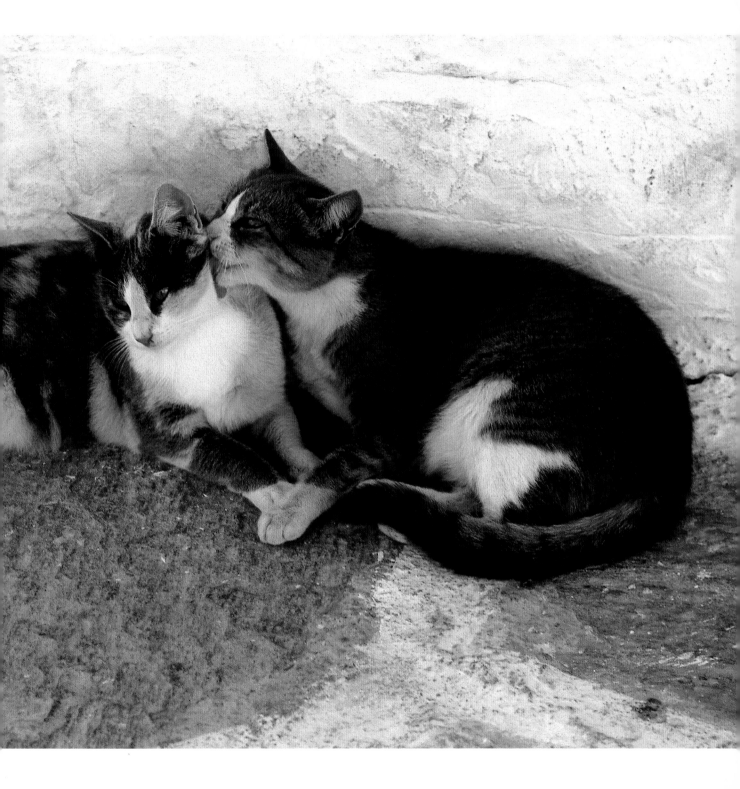

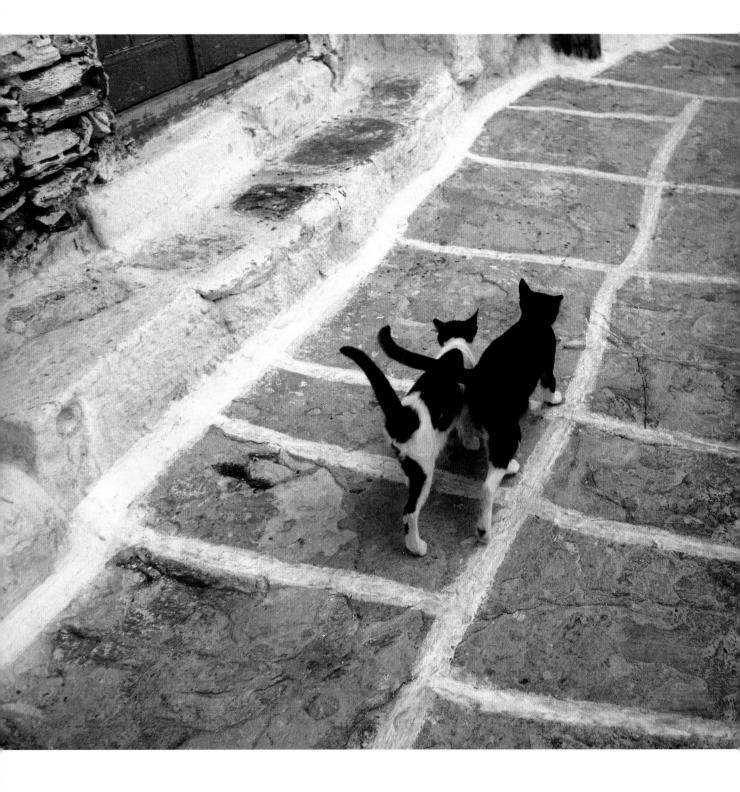

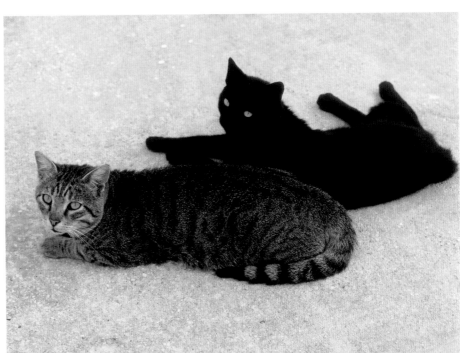
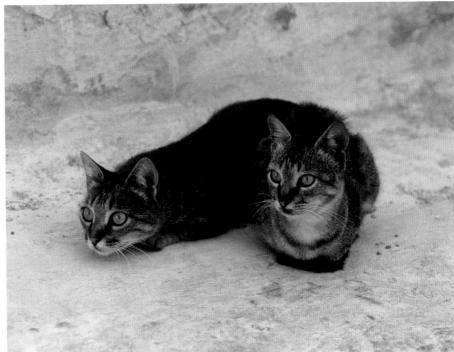

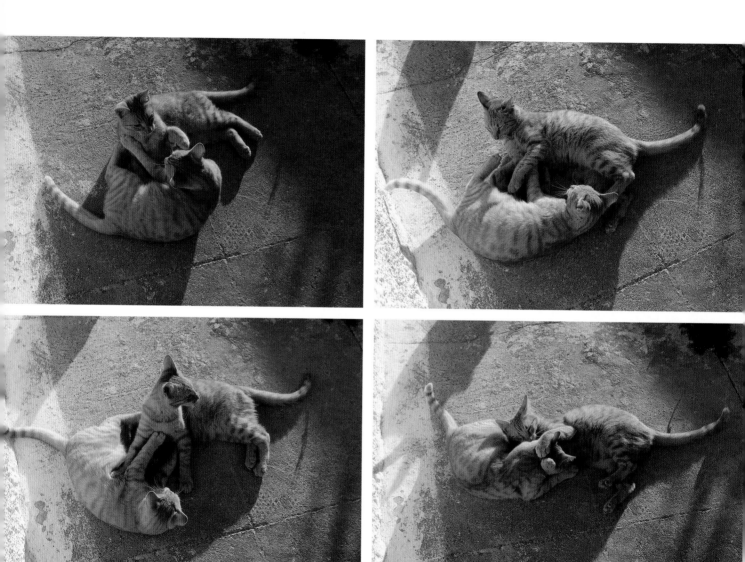

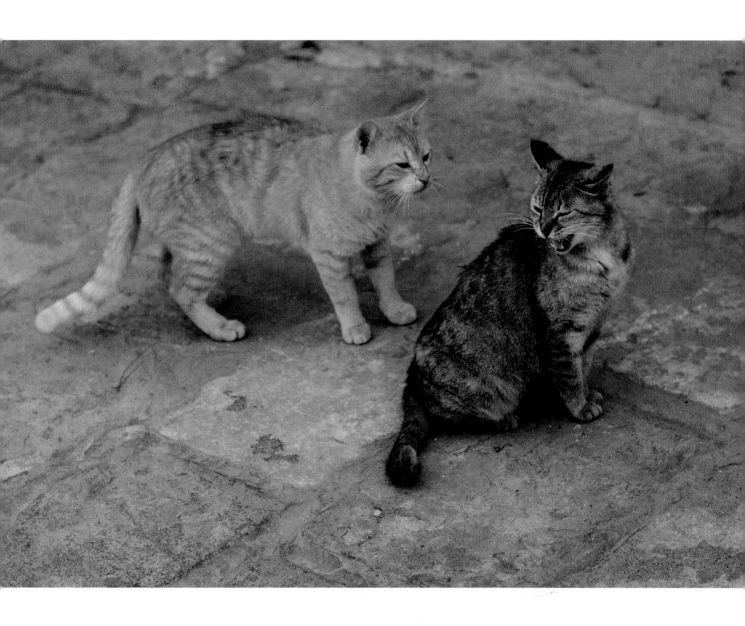

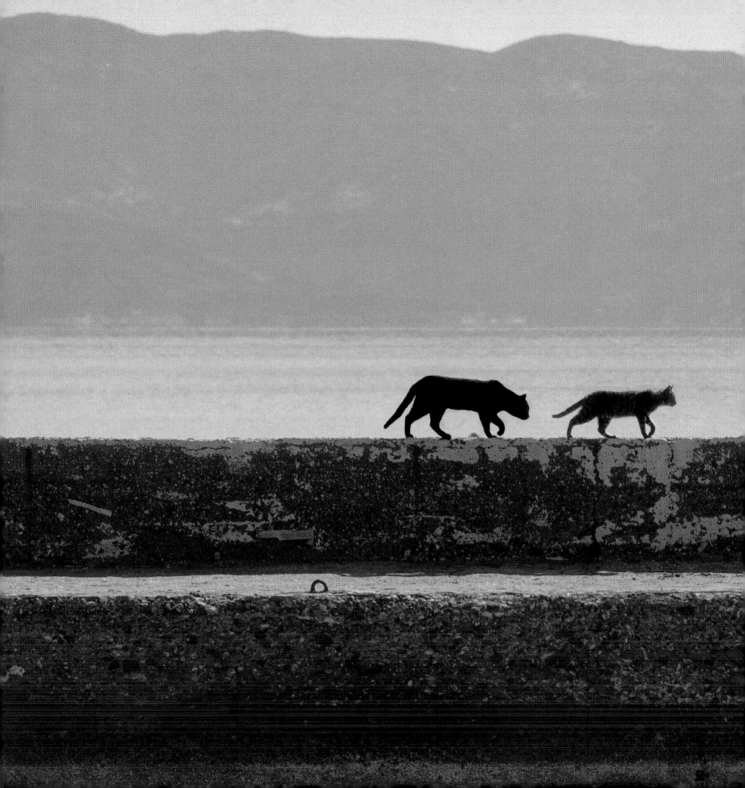

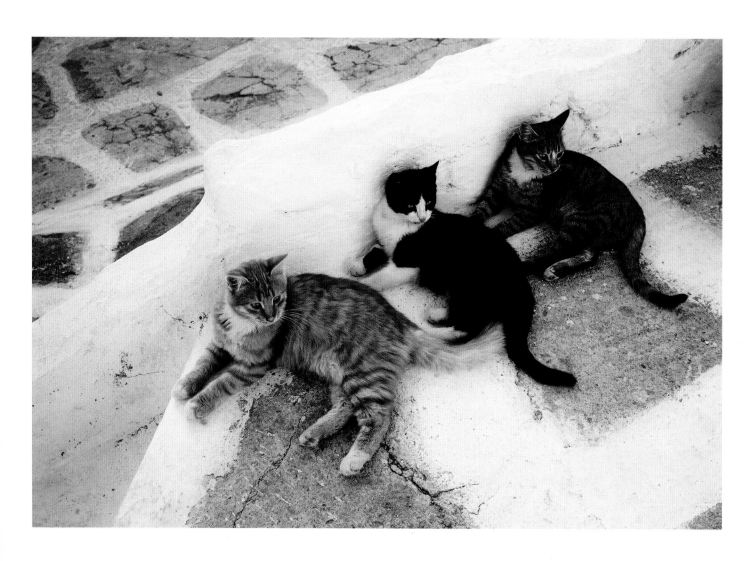

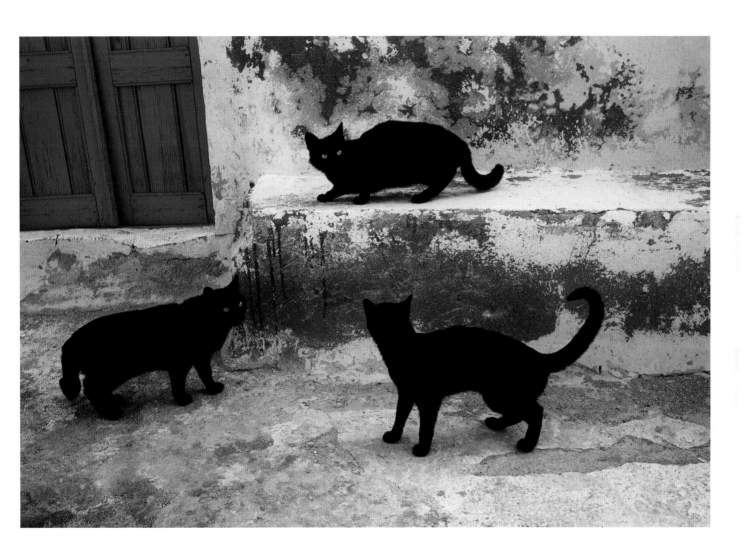

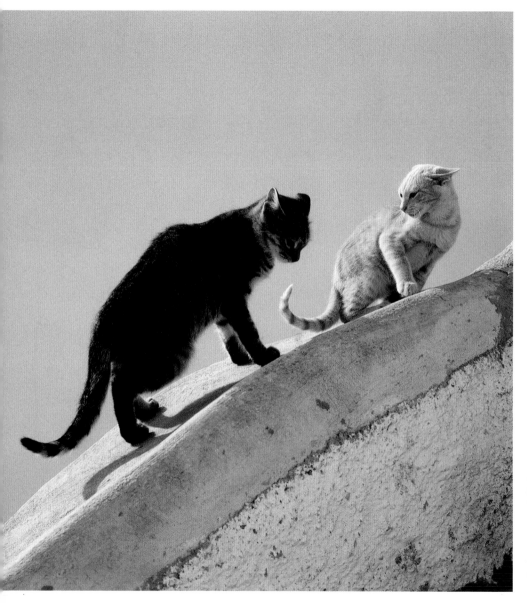

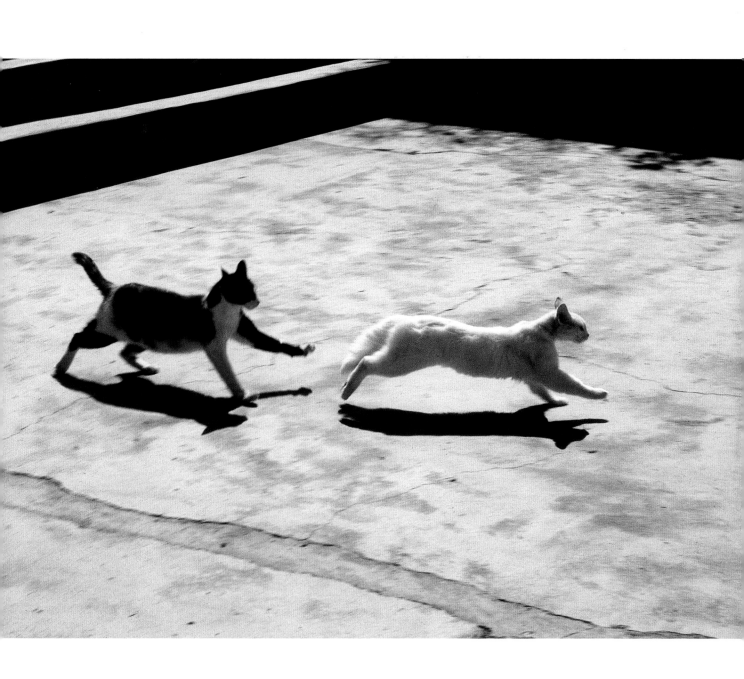

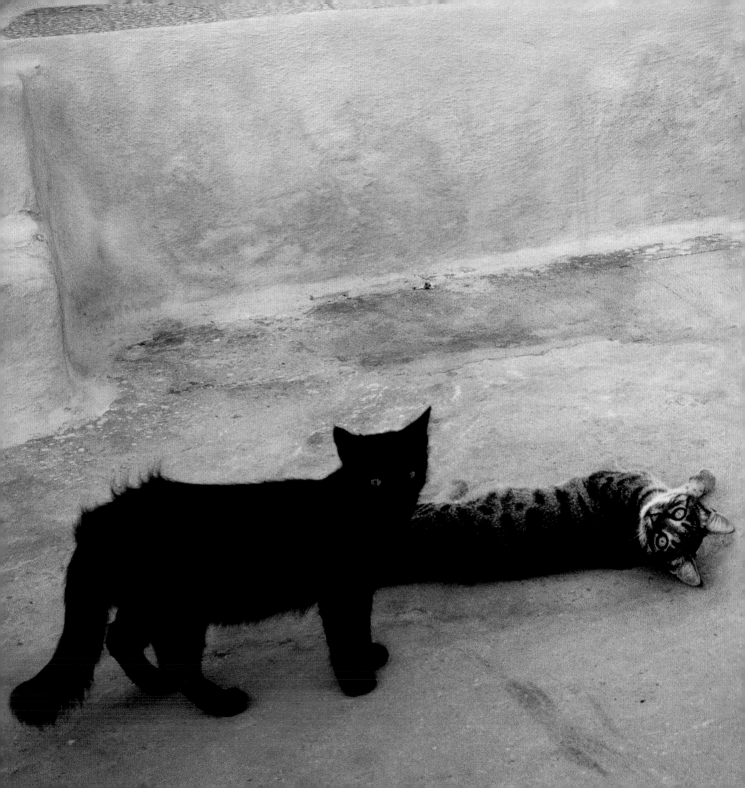

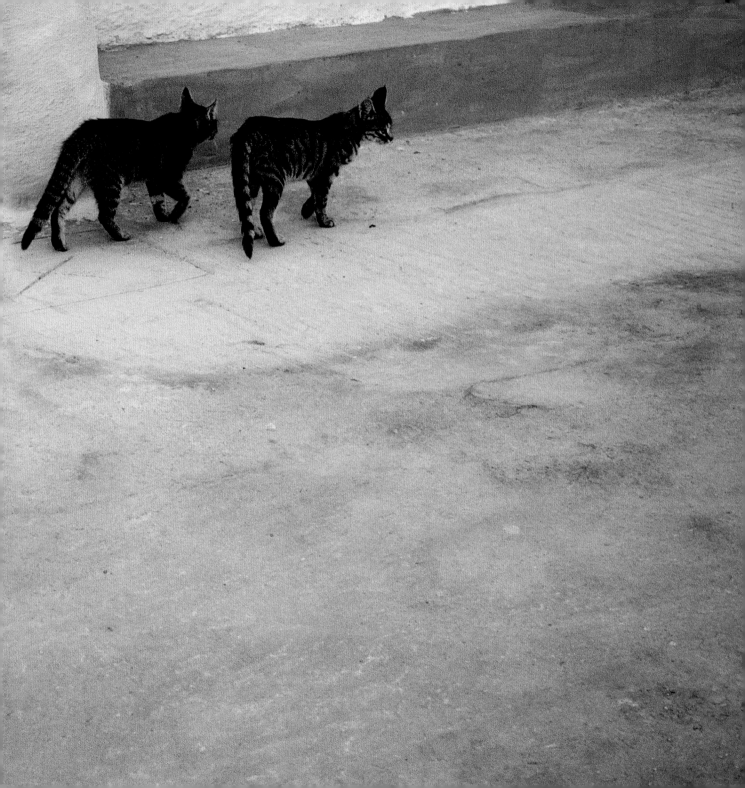

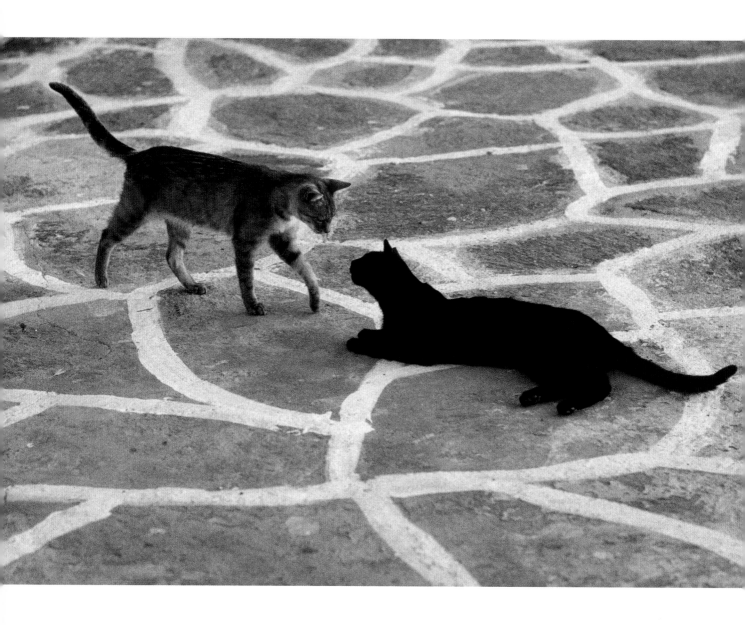

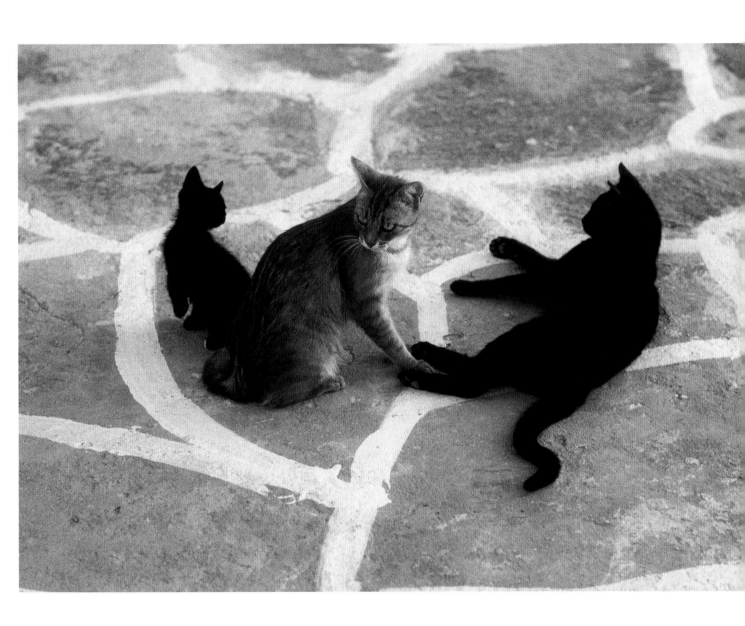

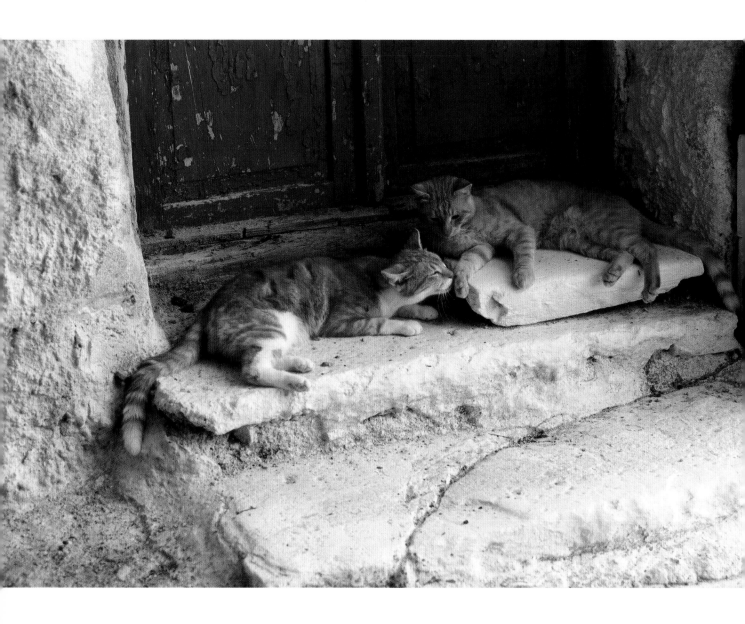

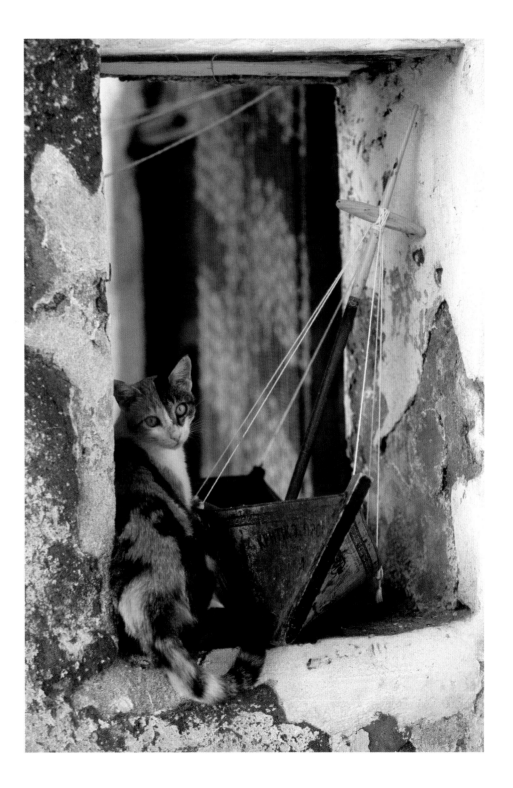

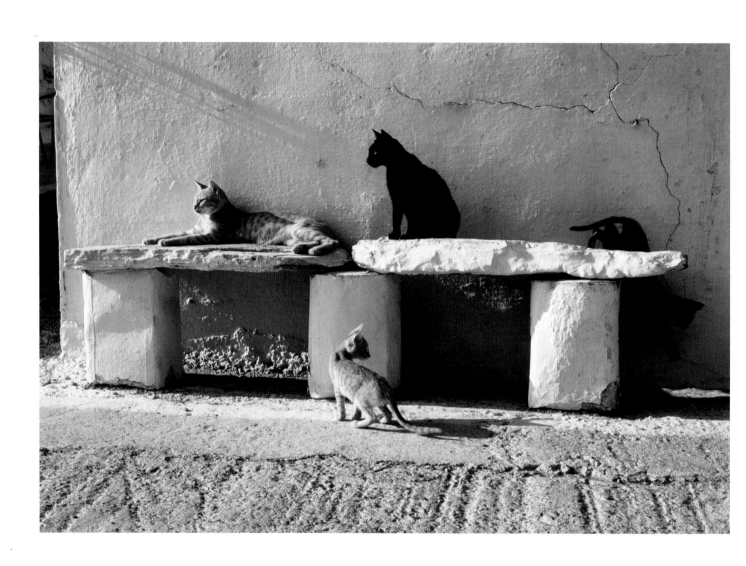

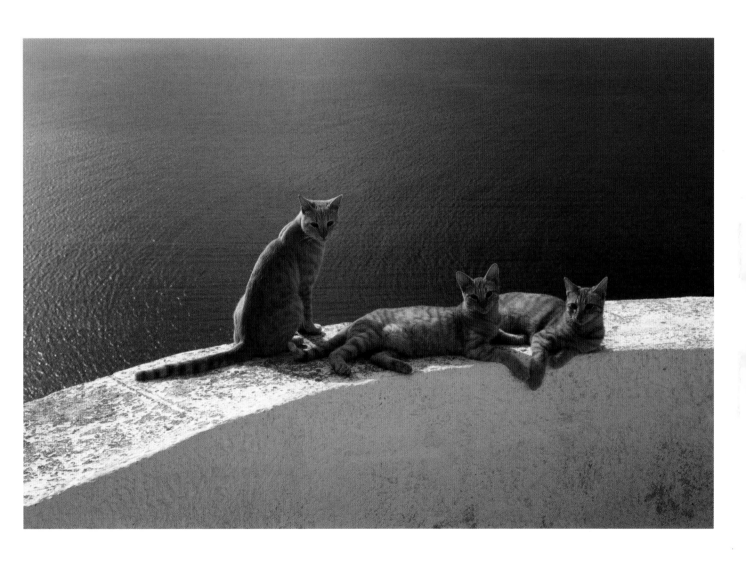

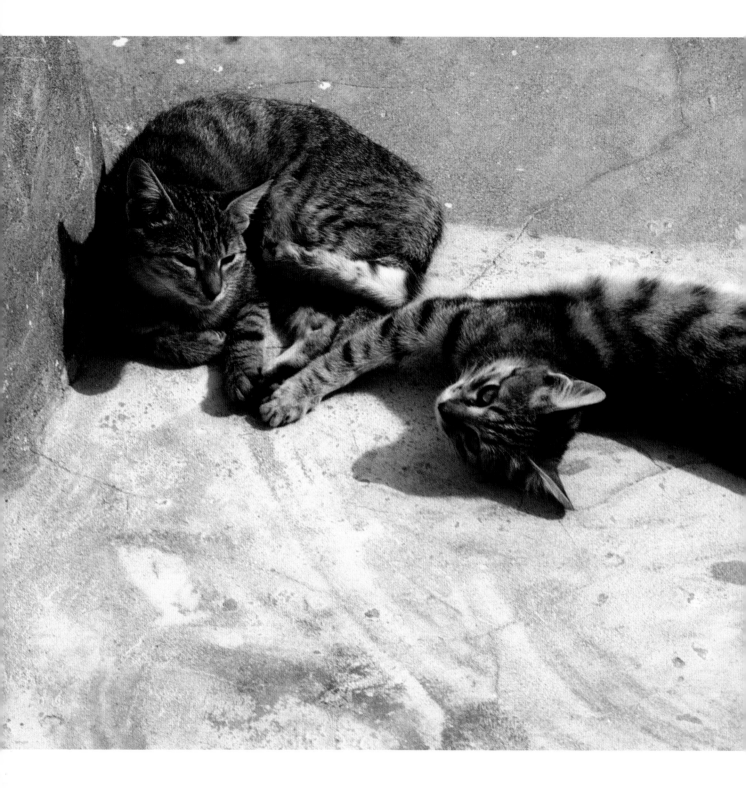

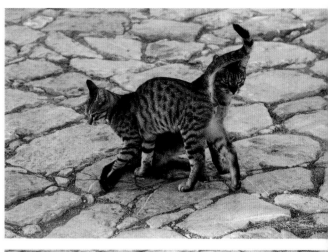
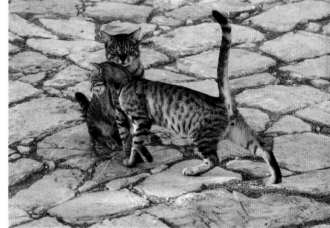
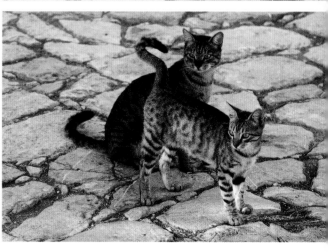

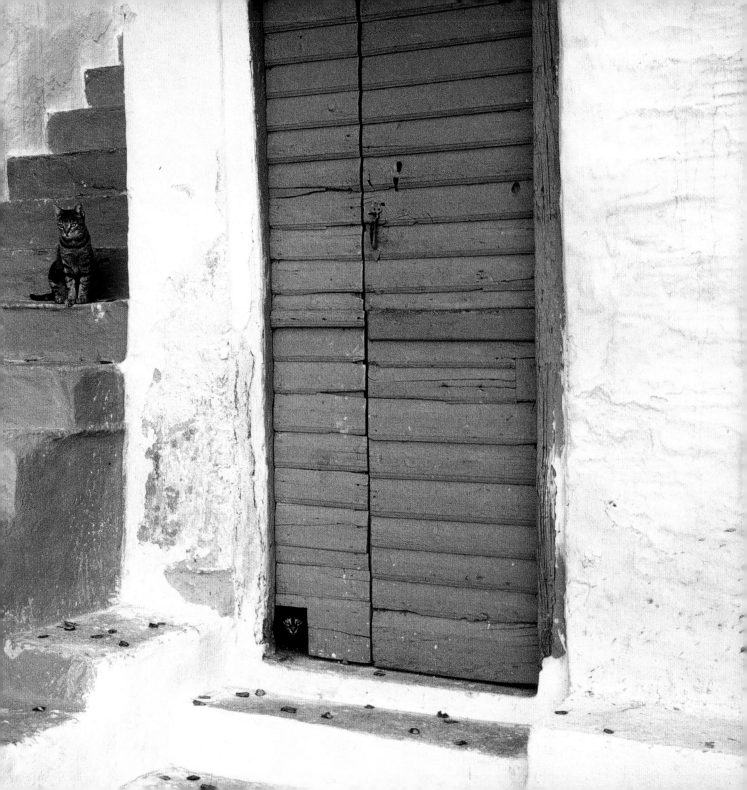

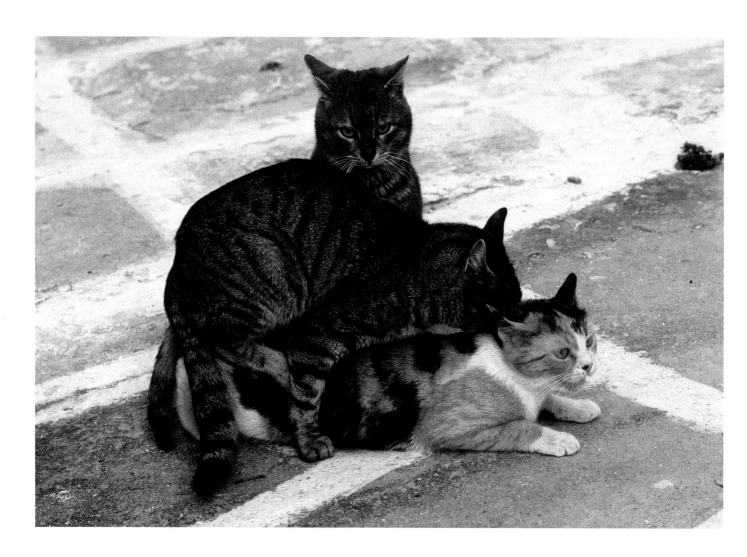

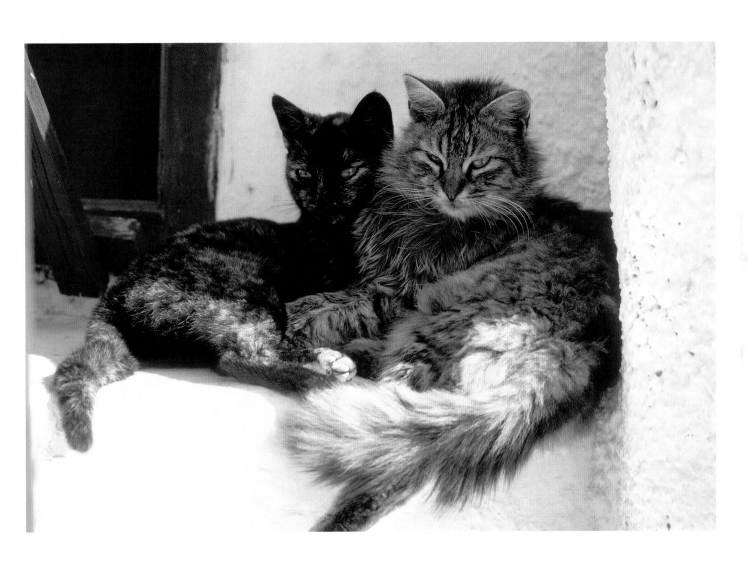

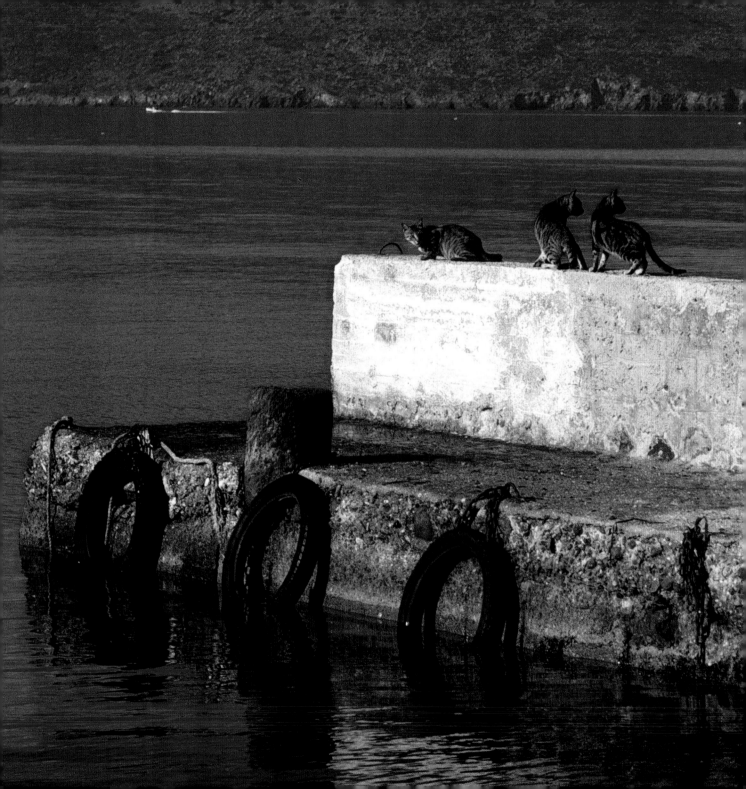

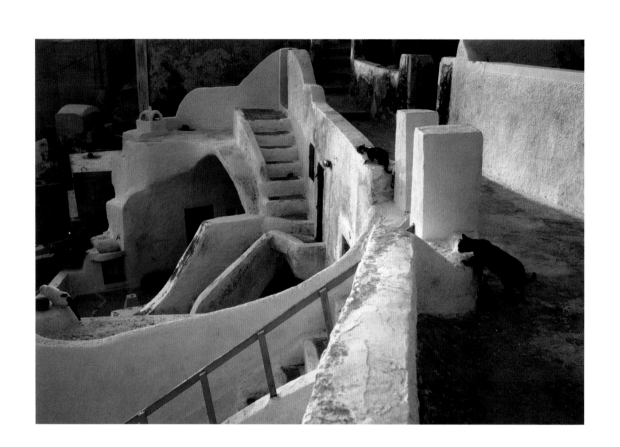